FEDERICO ZERI (Rome, 1921-1998), eminent art historian and critic, was vice-president of the National Council for Cultural and Environmental Treasures from 1993. Member of the Académie des Beaux-Arts in Paris, he was decorated with the Legion of Honor by the French government. Author of numerous artistic and literary publications; among the most well-known: *Pittura e controriforma*, the Catalogue of Italian Painters in the Metropolitan Museum of New York and the Walters Gallery of Baltimora, and the book *Confesso che ho sbagliato*.

Work edited by FEDERICO ZERI

Text
based on the interviews between
FEDERICO ZERI and MARCO DOLCETTA

This edition is published for North America in 2000 by NDE Publishing*

Chief Editor of 2000 English Language Edition
ELENA MAZOUR (*NDE Publishing**)

English Translation
SUSAN SCOTT

Realization
ULTREYA, MILAN

Editing
LAURA CHIARA COLOMBO, ULTREYA, MILAN

Desktop Publishing
ELISA GHIOTTO

ISBN 1-55321-012-3

Illustration references

Bridgeman/Alinari Archives: pp. 8as, 11b, 15a-c, 18, 27, 30-31, 32, 39, 41a-b, 42a, 43d, 44/I, 45/I-VI-XI-XIV.

Giraudon/Alinari Archives: pp. 1, 2-3, 4, 5, 6-7, 8b, 8-9, 11a, 16, 28, 28-29a-b, 44/XI, 45/IX.

Luisa Ricciarini Agency: pp. 10s, 13a-c, 34d, 40-41, 42b, 43as-bs, 45/V.

RCS Libri Archives: pp. 2a-b, 12, 14-15a-b, 15b, 17, 19, 20, 21, 22s, 22-23, 23a, 24, 25s-d, 26s-d, 29, 33, 34s, 35d, 36s-d, 37, 38-39, 40a-bs, 44/II-III-IV-V-VI-VII-VIII-IX-X-XII, 45/II-III-IV-VII-VIII-X-XII-XIII, 46d, 47s-ad.

R.D.: pp. 10d, 13b,14s-cd, 30, 35a, 38b, 40bd, 46as-bs, 47bd.

Printed and bound by Poligrafici Calderara S.p.A., Bologna, Italy

* a registered business style of NDE Canada Corp.
15-30 Wertheim Court, Richmond Hill, Ontario
L4B 1B9 Canada, tel. (905) 731-1288

The captions of the paintings contained in this volume include, beyond just the title of the work, the dating and location. In the cases where this data is missing, we are dealing with works of uncertain dating, or whose current whereabouts are not known. The titles of the works of the artist to whom this volume is dedicated are in blue and those of other artists are in red.

VERMEER
THE ASTRONOMER

This is a frequent subject in seventeenth century Flemish and Dutch art, but what distinguishes THE ASTRONOMER from genre painting and makes it unique is the handling of the light. The living light streams through the window on the left and becomes

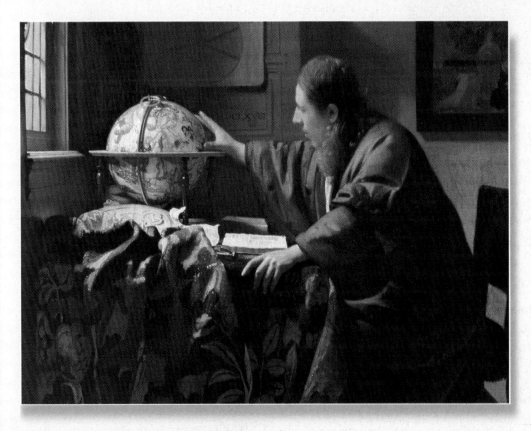

color, it gleams off fabrics and wood and circulates through the room, laying a silent veil over everything in it. The room loses its realistic connotations and becomes a moment of eternity suspended in silence.

THE MAGIC OF SILENCE

THE ASTRONOMER
1668-1673

● Paris, Louvre (oil on canvas, 46.3x50.8 cm)

● An inscription in the painting, on the cupboard door, seems to indicate that Vermeer painted this small picture in 1668. But many critics raise serious doubts as to whether the date and signature are autograph, and they tend to move the painting's execution until 1673, basing their judgment on aspects of technique which correspond with the last phase of the master's activity.

● The painting was probably conceived as a *pendant* to *The Geographer* in Frankfurt, a canvas similar to this one in both size and composition. In *The Astronomer*, the scholar touches the celestial globe on the table with his right hand, while in *The Geographer* he is intent on taking measurements from maps; according to some critics, these are maps of the heavens.

● Numerous hypotheses have been offered for identification of the figure of the learned man (seen also as a philosopher, astrologer, or mathematician) who serves as subject for these paintings. Some have seen in the elongated, beardless face framed by long hair the features of the philosopher Baruch Spinoza; others consider it Vermeer's self-portrait, which also appears in *The Geographer*, *The Procuress*, and *The Music Lesson*. Still others think it is Van Leeuwenhoek, the most important scholar of natural sciences in Delft; however, his portrait, painted by Jan Verkolje, does not seem to suggest a resemblance with the features of the person depicted in Vermeer's painting. Thus, although the two knew each other well, there is no proof for this fascinating hypothesis.

● The most evident trait distinguishing this painting is the vitality of the light, and it is this that makes it a masterpiece. Vermeer's use of light, which he handles with rare intelligence and sensitivity, derives from two important sources: one is the discoveries in painting made by the Flemish painter Van Eyck, the other is the phenomenon of northern Caravaggism, which reached its expressive zenith in France with Valentin, and in Holland and Flanders with Gerard Van Honthorst, Van Baburen, and Terbrugghen, whom Vermeer had occasion to know and appreciate. This very special light lies softly on persons and objects like a silent veil, infusing the entire atmosphere with magic.

◆ THE ASTRONOMER
This is one of the most beautiful works of the artist's final phase. Certain details of the painting can be identified: for example, the celestial globe on the table is by the Hondius family (see below) and the painting of *Moses Saved from the Water* is perhaps the one painted by Jacob Van Loo. Left, the presumed portrait of Vermeer as he appears in *The Geographer*.

◆ THE CELESTIAL GLOBE
The Hondius family were cartographers who made this mappemonde, reproduced by Vermeer in both *The Astronomer* and *The Geographer* and in *The Allegory of the Faith*.

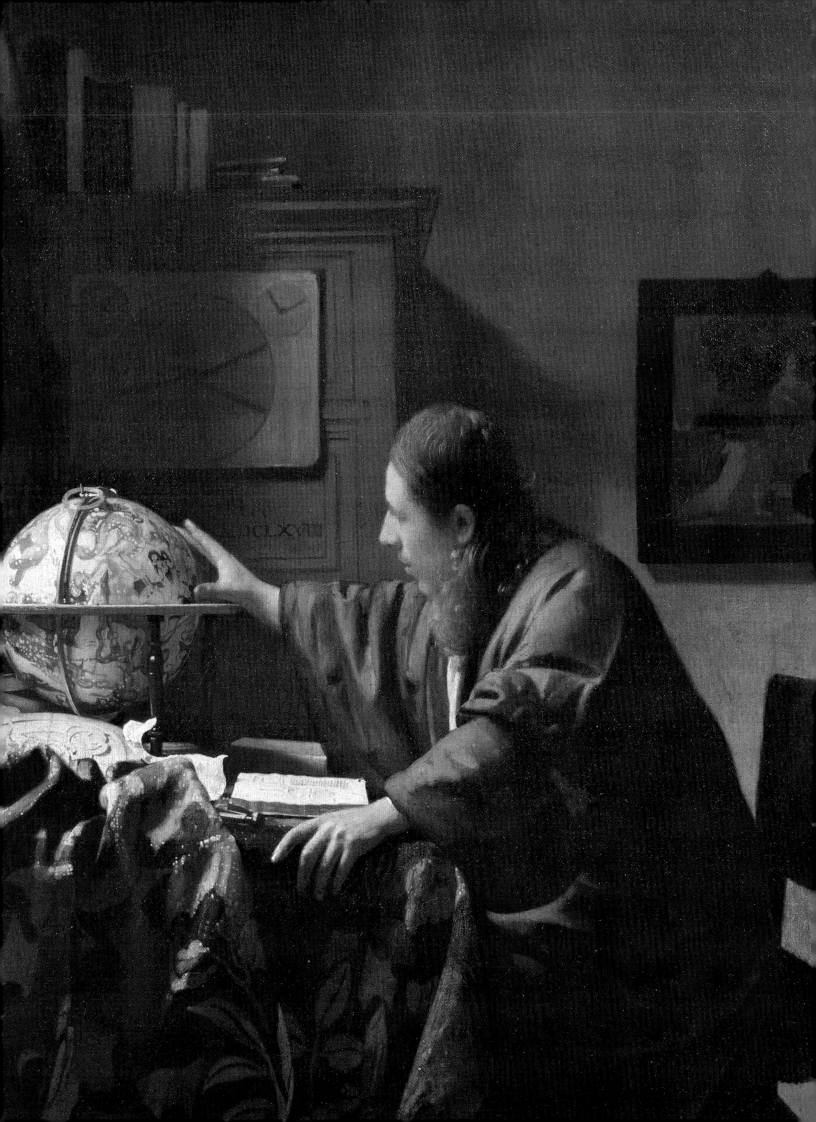

THE COLOR OF LIGHT

Vermeer's style stands out in the general panorama of Dutch art for his geometric sense of space, which is expressed in simplified, immobile forms and contributes to creating a rarefied, mysterious atmosphere. And too, his use of color is fundamental to the transposition from a real, domestic interior to an abstract, magical, evanescent dimension.

● Vermeer uses color as no one before him had, playing on the contrast between warm and cool tones. He chooses muted, dusty shades – especially characteristic are certain yellows and blues – but gives them resonance in short rapid brushstrokes, practically dots of paint on the canvas. The light is captured and bounces off small reflective surfaces; inkwells, silky fabrics, velvets, musical instruments, hair, jewel chests, glasses, polished wood.

● In *The Astronomer*, the rays of sunlight streaming through the window on the left of the painting break up on the tablecloth, the celestial globe, the man's clothing, his hair, vibrating in small details almost like luminous flames. Light becomes color. And color in turn sublimates and returns to light.

● The quality of Vermeer's painting lies precisely in this: in drawing with color and in shaping with light. But a particularly individual handling of the brush makes the overall picture glow from all the areas struck directly by the light sources. Minute dots of white paint are sprinkled over the objects, in a sort of *pointillisme* which the painter first adopts in his *Officer and Laughing Girl*.

● This extraordinary transformation of light and color constitutes the fundamental trait of Vermeer's art, which captures in this way the secret essence, the most hidden meaning of everyday life, through a collection of objects in common use, which in his hands become symbols.

◆ REFLECTION
The detail highlights the gesture of easy familiarity by which the scholar establishes a tactile, as well as speculative, relationship with the objects used for his research. One hand is near the book, representing theory, while the other rests on the celestial globe, representing everything that experimental science has been able to verify.

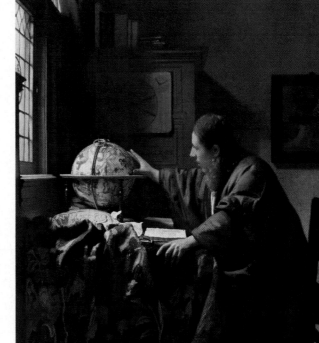

In the allusive value of the astronomer's gesture lies all the painting's mystery.

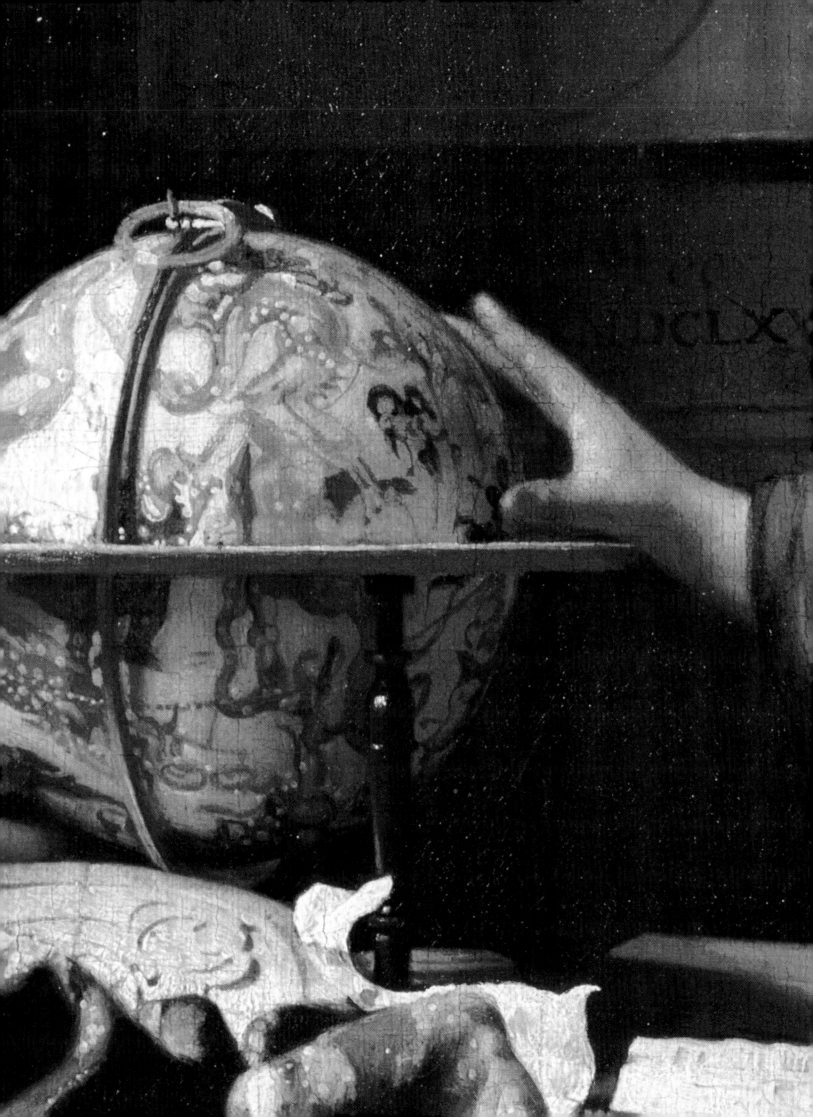

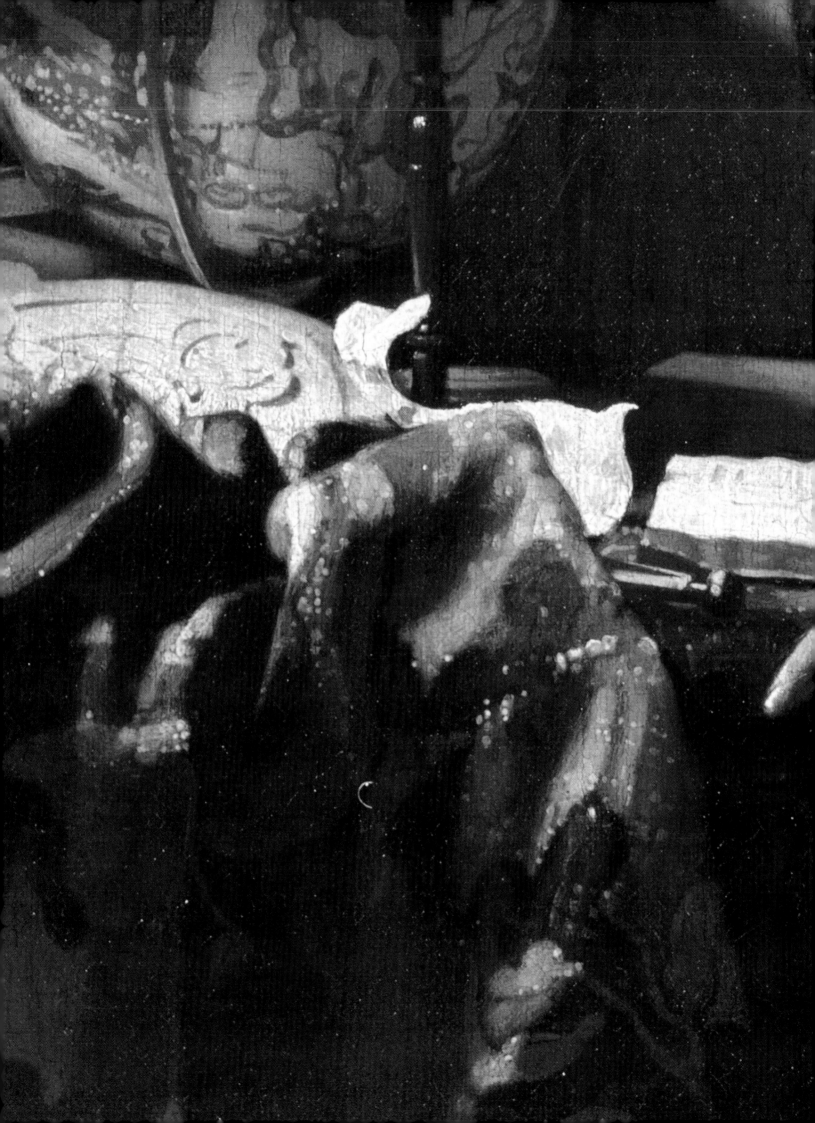

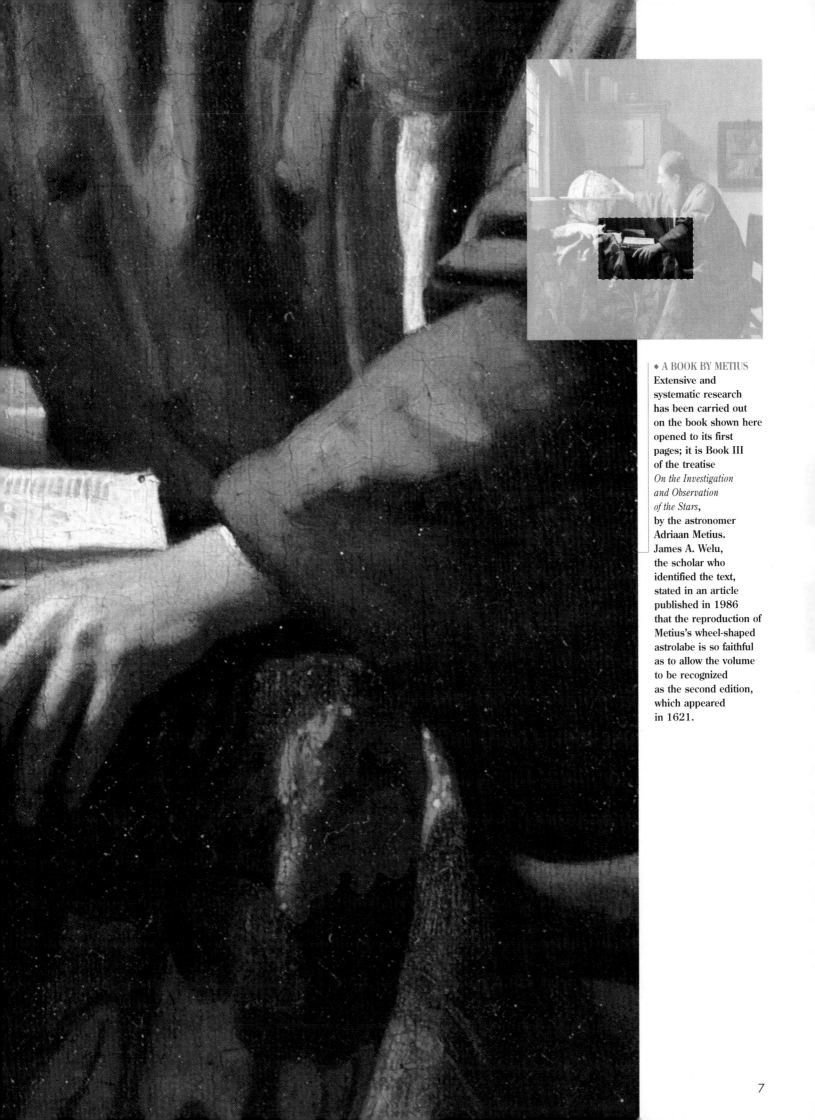

◆ A BOOK BY METIUS
Extensive and
systematic research
has been carried out
on the book shown here
opened to its first
pages; it is Book III
of the treatise
*On the Investigation
and Observation
of the Stars*,
by the astronomer
Adriaan Metius.
James A. Welu,
the scholar who
identified the text,
stated in an article
published in 1986
that the reproduction of
Metius's wheel-shaped
astrolabe is so faithful
as to allow the volume
to be recognized
as the second edition,
which appeared
in 1621.

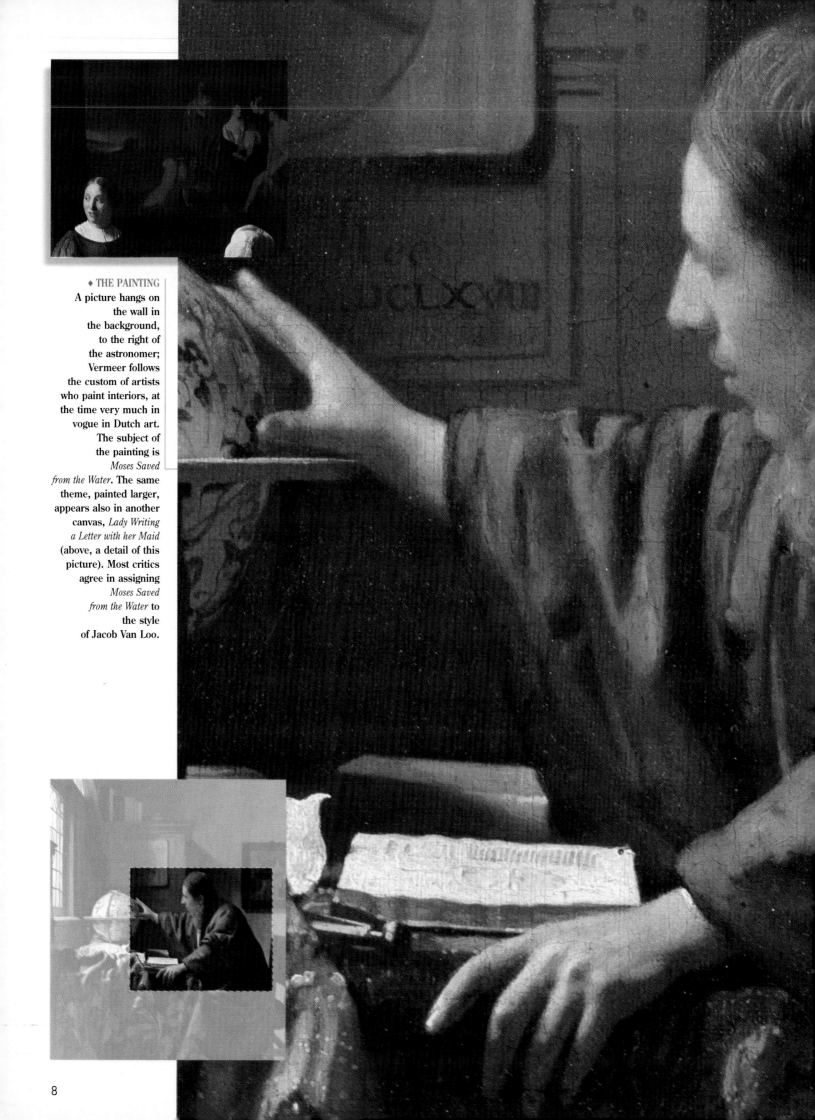

♦ THE PAINTING

A picture hangs on the wall in the background, to the right of the astronomer; Vermeer follows the custom of artists who paint interiors, at the time very much in vogue in Dutch art. The subject of the painting is *Moses Saved from the Water*. The same theme, painted larger, appears also in another canvas, *Lady Writing a Letter with her Maid* (above, a detail of this picture). Most critics agree in assigning *Moses Saved from the Water* to the style of Jacob Van Loo.

A SUSPENDED INSTANT OF ETERNITY

The remarkable renewal of interest in astronomy during the seventeenth century came about as much for the progress made in theoretical research – which, before Newton, reached a zenith in the work of Kepler – as for the extraordinary developments, both quantitative and qualitative, in observation. The unprecedented results achieved in the investigation of heavenly bodies depended without doubt on the introduction of new instruments, first of all the telescope. Galileo's discoveries and inventions made an incalculable contribution to the spread of the practice of observing the heavens.

● The figure of the astronomer, or more simply of the amateur observer, became increasingly familiar during this century and was the subject of numerous portraits. Dutch artists like Paulus Morales, Cornelius De Man, and Ferdinand Bol, a student of Rembrandt, all dealt with the theme in painting.

● Within Vermeer's artistic production, paintings like *The Astronomer* and *The Geographer*, more than portraying specific scholars, seem to capture the intimate, medititative moment of the intellectual pastime of a cultured middle class that enjoyed working with scientific tools. This explains the tendency to see the subject of this painting as a kind of self-portrait, more than the portrait of Baruch Spinoza or Van Leeuwenhoek.

● The setting, although described in meticulous detail, in its function as atmospheric *medium* loses its realistic impact in favor of a strongly abstract, intellectual, timeless dimension.

◆ THE FARNESE ATLAS (copy of the 2^nd century Hellenistic original, Naples, Museo Nazionale). This is the first representation of the terrestrial globe. The myth of Atlas holding up the vault of the sky furnishes the title for the collection of maps published by Mercator in 1595.

◆ OBSERVATION OF THE HEAVENS At right is an illustration, showing instruments for observing the sky, taken from the *Selenografia sive Lunae descriptio* by the astronomer Johannes Hevelius, the author in 1649 of the first atlas of the moon.

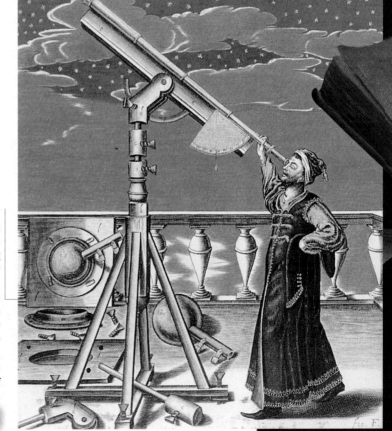

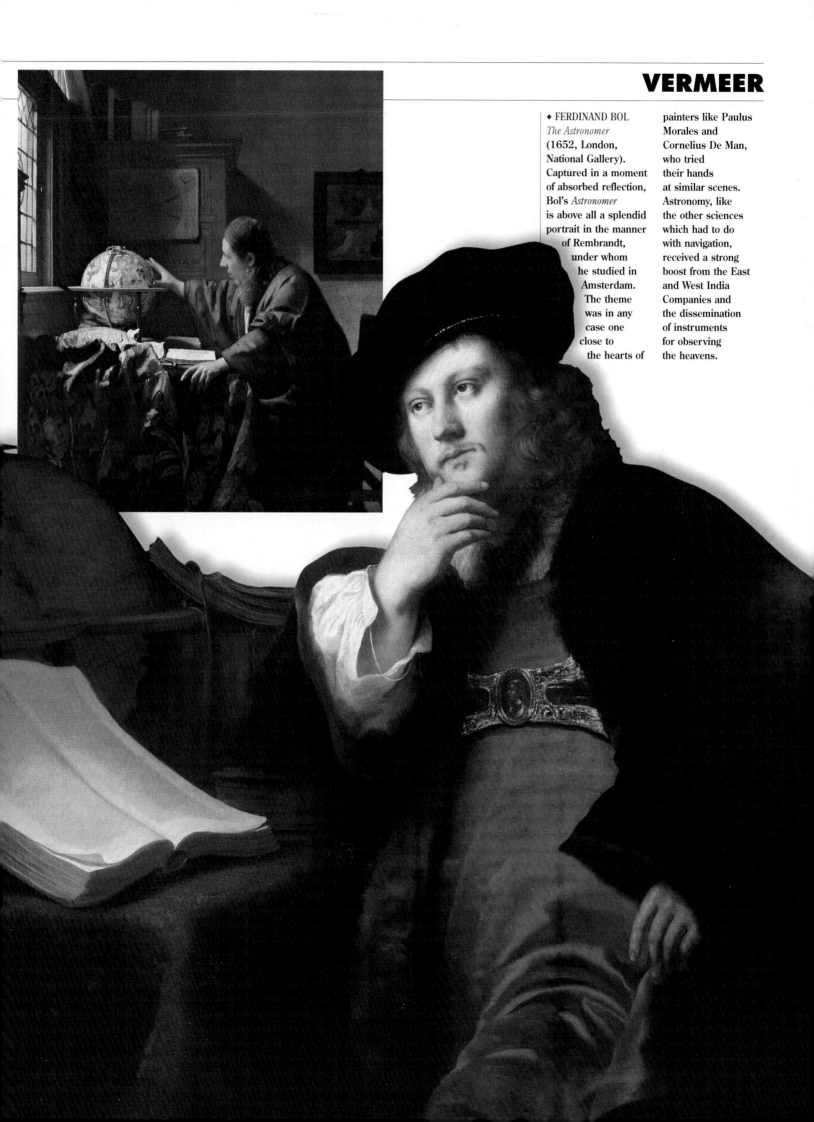

VERMEER

◆ FERDINAND BOL
The Astronomer
(1652, London,
National Gallery).
Captured in a moment
of absorbed reflection,
Bol's *Astronomer*
is above all a splendid
portrait in the manner
of Rembrandt,
under whom
he studied in
Amsterdam.
The theme
was in any
case one
close to
the hearts of
painters like Paulus
Morales and
Cornelius De Man,
who tried
their hands
at similar scenes.
Astronomy, like
the other sciences
which had to do
with navigation,
received a strong
boost from the East
and West India
Companies and
the dissemination
of instruments
for observing
the heavens.

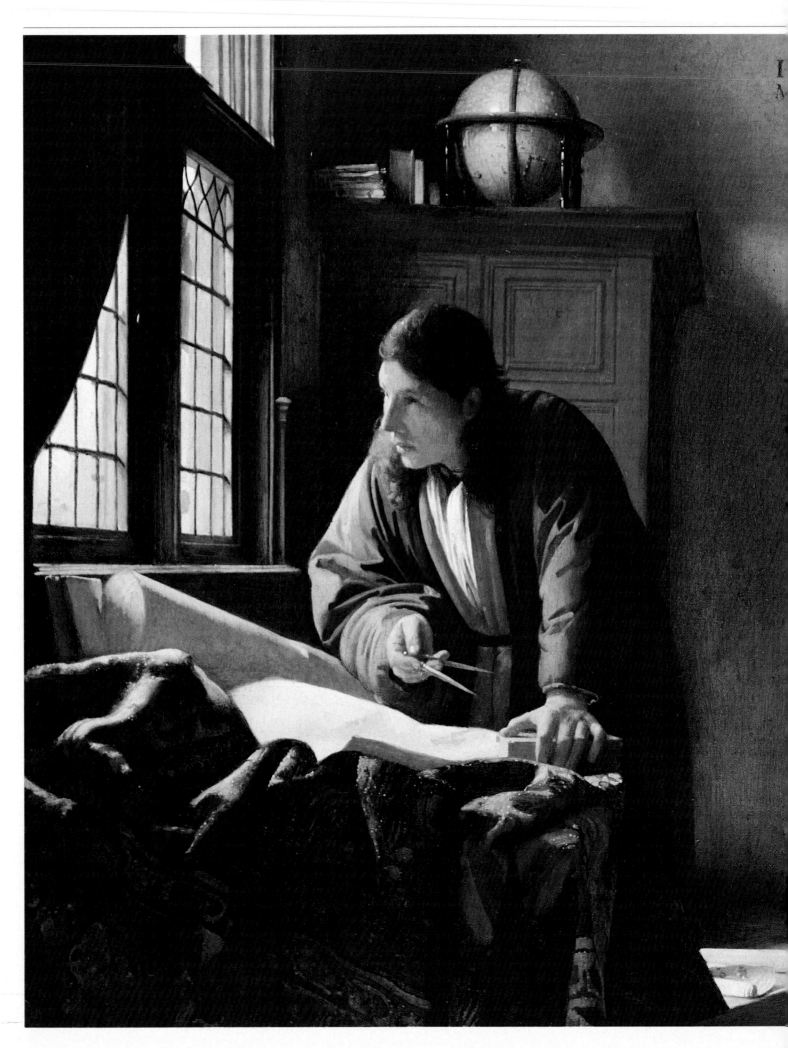

◆ JAN BRUEGEL AND PIETER PAUL RUBENS
Allegory of Sight and Smell
(after 1618, Madrid, Prado).
Like other Flemish painters, Jan Bruegel and Rubens also succumbed to the allure of science. A small still life of scientific instruments used for observing the sky is inserted into this painting.

◆ MERCATOR AND HONDIUS
The two famous cartographers are joined in an image of the *Atlas sive cosmographicae meditationes de fabrica mundi et fabricati figura* by Gerhard Kremer, better known as Mercator. The term "Atlas" was used here for the first time by Mercator to indicate a collection of maps. The volume gave an organic organization to cartographic knowledge of the time.

◆ THE GEOGRAPHER
(c. 1669, Frankfurt, Städelsches Kunstinstitut).
For years thought to be the *pendant* of *The Astronomer*, *The Geographer* could in reality be a variation. Supporting this hypothesis is the presence of a celestial globe on the cupboard and the map open on the table, which seems to be more a map of the heavens than of the earth. The two paintings, furthermore, were often sold as a pair at auctions in the first half of the eighteenth century.

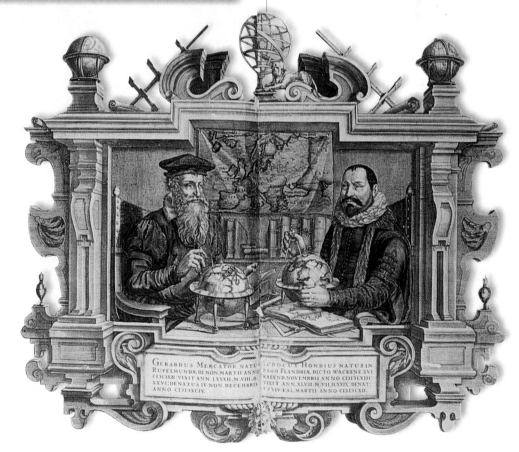

SILENCE AND LIGHT

I t is not known if Jan Vermeer of Delft had a teacher in the usual sense of the word. Certainly he was able to know and appreciate the work of the Dutch Caravaggists and Rembrandt, and to rework in a completely original way their rendering of light, which became the essential element of his painting.

● A certain familiarity with the art world came to him from his father, a hotelier and art merchant in Delft. Some painters, like Egbert Van der Poel, had made it a habit to stay in the Vermeers' Hotel Mechelen when they were in Delft.

● His start in painting must have come quite early, if the artist could already in 1653 be part of the local Guild of St Luke, of which he was dean (the Dutch phrase translates as "headman") in 1662-63 and in 1672. His contemporaries showed a solid appreciation for his art during his lifetime, but this was a small thing compared to the acclaim awarded it starting in the nineteenth century, thanks also to Marcel Proust, who was one of the first to discern its secrets and its greatness.

● And it is precisely silence that constitutes the tie between Vermeer and Proust. The search for lost time finds in silence the primary condition for exercising memory, which is possible only when the urgencies of life are stilled and a muffled calm is established, the quiet typical of Vermeer's interiors, conducive to introspection.

● The artist's untimely death in 1675, at only 43 years of age, was probably the main cause of the rapid oblivion into which his work fell, lasting for about two centuries. But contributing to its neglect was also the difficulty of understanding the insistence with which he explored, with discretion and perseverance, certain subjects in order to capture the fleeting moment, their fragile appearance, and render them eternal.

♦ MARCEL PROUST
The writer, in his famous *In Search of Lost Time*, but also in other writings, devotes great attention to the artist whom he calls his "favorite master." A great affinity exists between him and the seventeenth century painter, with whom he shares the search for a reality that transcends the immediate data which can be perceived by the senses. He cites Vermeer's works often in his pages, demonstrating the competence of a refined art expert.

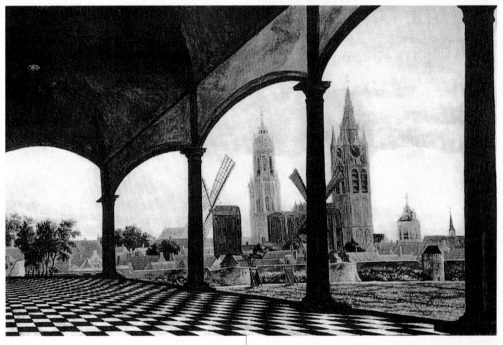

♦ DANIEL VOSMAER
View of Delft
(1665, Delft, Het Prinsenhof Museum). The city of Delft was not a site of great cultural ferment if compared to Leyden, Utrecht, or Amsterdam; it lacked theater, literature, music, and poetry. Only painting was well represented, and the Guild was thus at the center of public life for Vermeer, who had contacts also with the masters active in the city's celebrated porcelain manufacture.

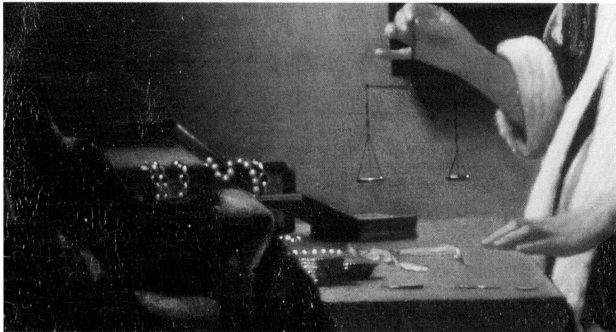

◆ FRAGMENTS OF LIGHT
An overall selection of some details, each from a different painting by Vermeer, allows us to observe closely what was said earlier about the technique of *pointillisme*. At the same time, the importance can be noted – in the balance between light and shadows – of what appear as veritable luminous flames, capable of breaking through the areas of shadow and transmitting and propagating the natural light reflected on the objects.

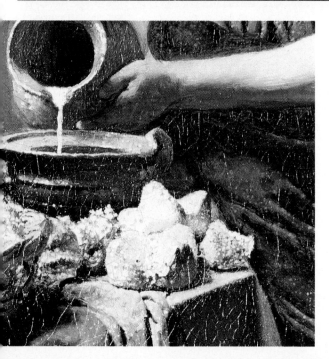

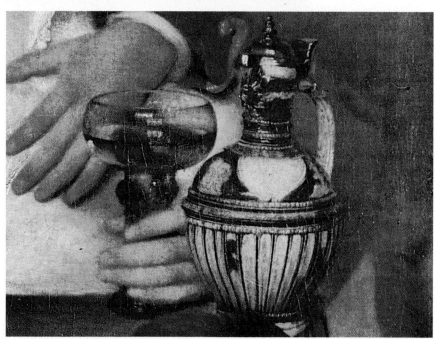

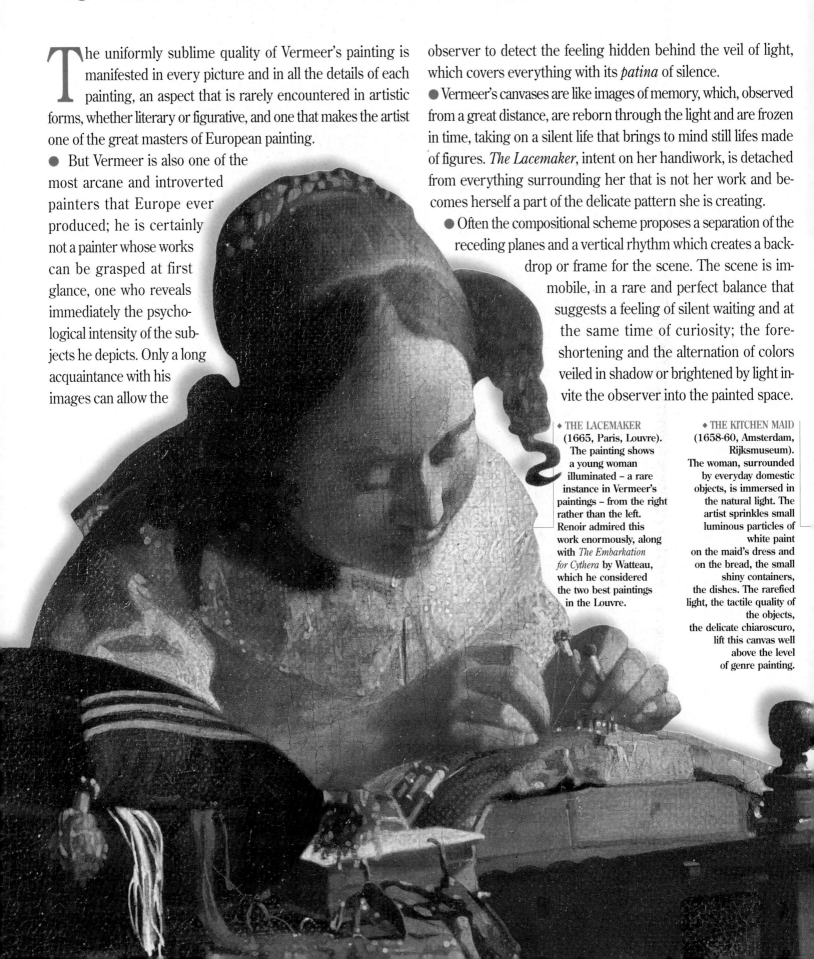

"STILL LIFE" OF FIGURES

The uniformly sublime quality of Vermeer's painting is manifested in every picture and in all the details of each painting, an aspect that is rarely encountered in artistic forms, whether literary or figurative, and one that makes the artist one of the great masters of European painting.

● But Vermeer is also one of the most arcane and introverted painters that Europe ever produced; he is certainly not a painter whose works can be grasped at first glance, one who reveals immediately the psychological intensity of the subjects he depicts. Only a long acquaintance with his images can allow the observer to detect the feeling hidden behind the veil of light, which covers everything with its *patina* of silence.

● Vermeer's canvases are like images of memory, which, observed from a great distance, are reborn through the light and are frozen in time, taking on a silent life that brings to mind still lifes made of figures. *The Lacemaker*, intent on her handiwork, is detached from everything surrounding her that is not her work and becomes herself a part of the delicate pattern she is creating.

● Often the compositional scheme proposes a separation of the receding planes and a vertical rhythm which creates a backdrop or frame for the scene. The scene is immobile, in a rare and perfect balance that suggests a feeling of silent waiting and at the same time of curiosity; the foreshortening and the alternation of colors veiled in shadow or brightened by light invite the observer into the painted space.

◆ THE LACEMAKER (1665, Paris, Louvre). The painting shows a young woman illuminated – a rare instance in Vermeer's paintings – from the right rather than the left. Renoir admired this work enormously, along with *The Embarkation for Cythera* by Watteau, which he considered the two best paintings in the Louvre.

◆ THE KITCHEN MAID (1658-60, Amsterdam, Rijksmuseum). The woman, surrounded by everyday domestic objects, is immersed in the natural light. The artist sprinkles small luminous particles of white paint on the maid's dress and on the bread, the small shiny containers, the dishes. The rarefied light, the tactile quality of the objects, the delicate chiaroscuro, lift this canvas well above the level of genre painting.

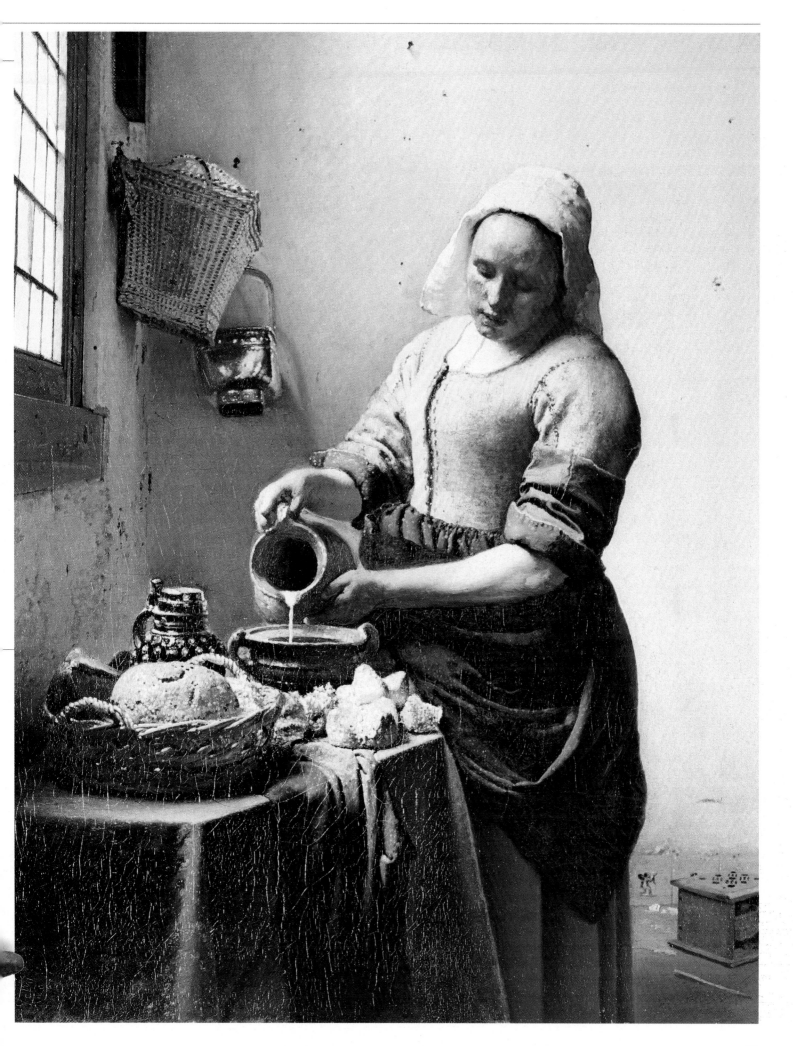

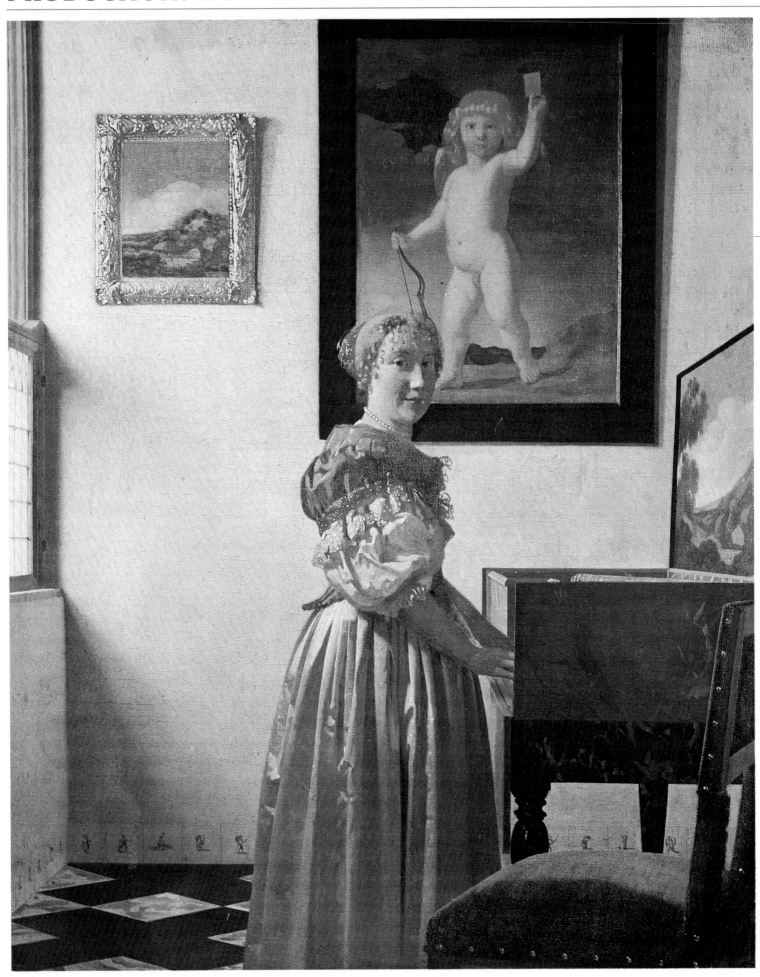

◆ LADY STANDING
AT A VIRGINAL
(1671, London,
National Gallery).
Some critics have seen
in this painting signs
of a decline on the part
of the artist, who here
gives a virtuouso
rendering of some
of his favorite themes.
The brilliant light and
reflections are thought
excessive for a master at
the height of his career.
In reality, this interior,
always the same and yet
ever new, is striking.
The large painting
in the background could
be a *Love Triumphant*
in the style of Van
Everdingen, already seen
in *Girl Asleep* and in *Girl
Interrupted at her Music*.
The virginal with
the keyboard on
the right, typical of
the Netherlands, returns
in other paintings.
Here its top is decorated
with a woodlands scene.

◆ GIRL ASLEEP
(c. 1657, New York,
Metropolitan
Museum of Art).
Intense shades of red
and yellow and
the colored tablecloth in
the foreground link this
painting to another one
from the same years,
The Procuress. But here
a rigorous organization
of space begins to be
evident. Attention is
focused on the middle
ground, where
the central element of
a still life with a figure
is placed, so that all
the rest of the picture,
even though
meticulously described,
does not distract
the viewer's gaze from
the subject. Notice
the foreshortened chair
in the foreground,
typical of many of
Vermeer's paintings,
both for its placement
and for the lion's
head finials
on its back.

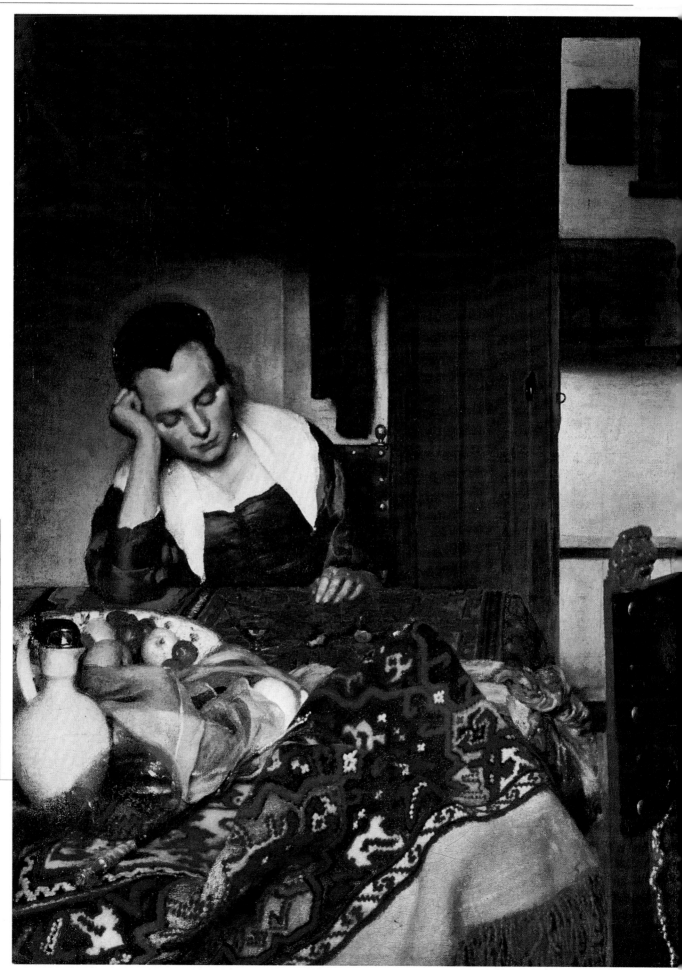

PRODUCTION: DOMESTIC INTIMACY

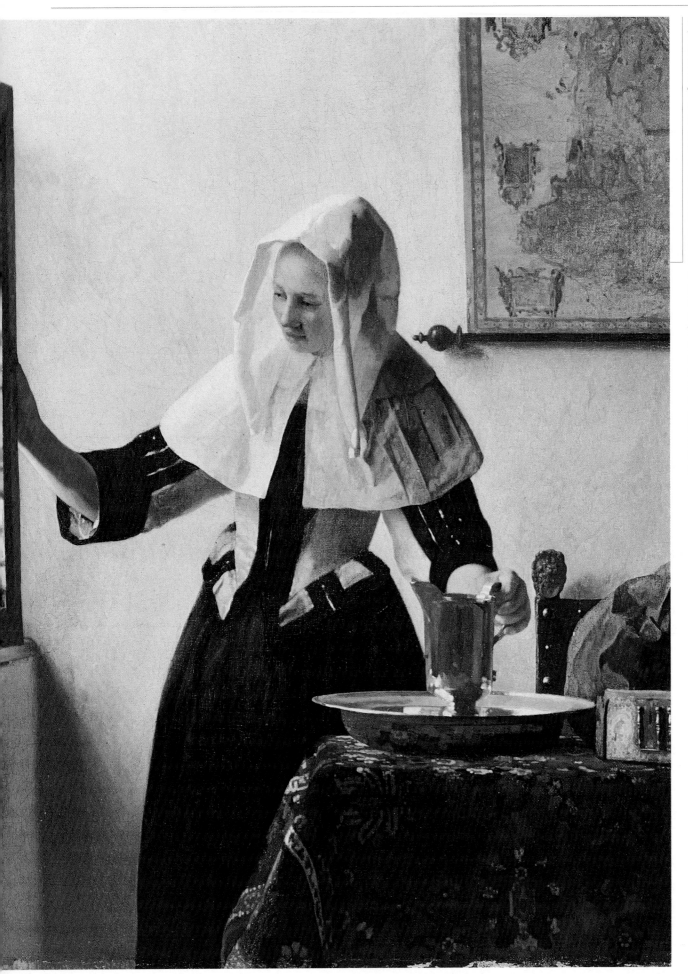

◆ YOUNG WOMAN
WITH A WATER JUG
(1658-60, New York,
Metropolitan
Museum of Art).
The painting, for its
ecstatic, contemplative
immobility, takes its
place among
the greatest and most
refined of the artist's
creations. Recurrent
motifs appear in
the scene: the map of
Europe, the chairs with
the lions' heads,
the jewel chest, the
Oriental rug, the girl's
corset (the same as
the one worn by the
*Lady Reading a Letter
at an Open Window*).
The basin and jug throw
off gleams of light, as
do the studs on
the chair. A triumph of
blues, red, and yellows,
muted by a dusting of
gray sprinkled also on
her stole and white
headdress, shapes and
highlights the volumes
in this painting.

◆ LADY WITH A STRING
OF PEARLS
(1662, Berlin,
Staatliche Museen).
The young woman
looking at herself
in the mirror,
especially
at the string of pearls
around her neck,
is wearing the same
yellow jacket trimmed
with ermine that
appears in six of
Vermeer's paintings.
Her luminous figure
stands out against
the bare wall, while
in the foreground
the objects are
immersed in dark
shadow, interrupted
by the chair set
diagonally
in the full light.
The blue cloth on the
table is the same one
we see in *A Lady
Weighing Gold* and
the *Lady Writing a Letter*.

20

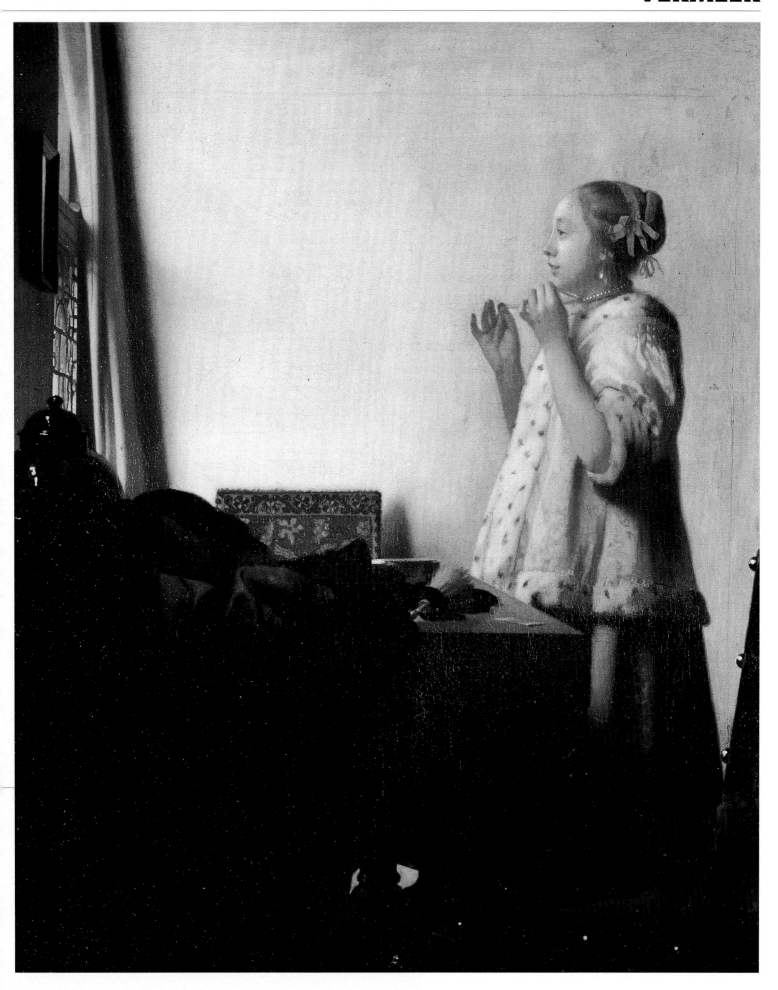

THE AMOROUS EVENT

◆ THE LOVE LETTER
(1667, Amsterdam, Rijksmuseum).
The structure of the painting appears quite complex, being divided into three parts both vertically and in the planes receding into depth; the viewer is on this side of the open door, beyond it the principal scene takes place, and in the background hang two landscapes, one above the other. The seated woman holding the lute is richly dressed and jeweled; in the left foreground is a map, and on the right musical scores.

Vermeer's emotional life must have known moments of intense feeling: we note that in 1653, a year after his father's death, he was united in marriage with Catharina Bolnes, a Catholic. Their betrothal was opposed by her mother for social and religious reasons: the girl belonged to a well-to-do family of a higher rank than Vermeer's, who was Protestant and did not enjoy a flourishing financial situation. The painter, for love, converted to Catholicism; while this allowed him to marry, it cut him off from a series of contacts and possible commissions in an environment like that of Delft, which was predominantly Calvinist.

● One of the most frequently recurring themes in the artist's work is the love letter, present in the paintings in the act of being written or read or given to a messenger; whatever the context, it is always the symbol of communication and understanding between two people united by a bond of love. The figures appearing in the scene are not depicted with emphatic expressions or poses, but in the intensity and ecstatic immobility of simple, natural gestures.

● Going beyond genre painting, which depicts daily occupations and activities or the customs of a society meticulously described in its usual habitat, Vermeer seeks in his painting the unsaid, the unexpressed: intimacy, a meeting, a dialogue, complicity, something more than "a secretly watched scene."

◆ OFFICER AND LAUGHING GIRL (c. 1657, New York, Frick Collection). The theme of the encounter between a man and a woman is given an extraordinary rendition in this painting, which still belongs to Vermeer's early phase. The light enters through the window and spreads brightly through the room. Contrast is offered between the figure of the soldier in the foreground, represented in a foreshortened position and in shadow, and the smiling girl in full sunlight, who holds a glass of wine in her hands, a recurrent motif in pictures of encounters. The table between them gives depth to the scene.

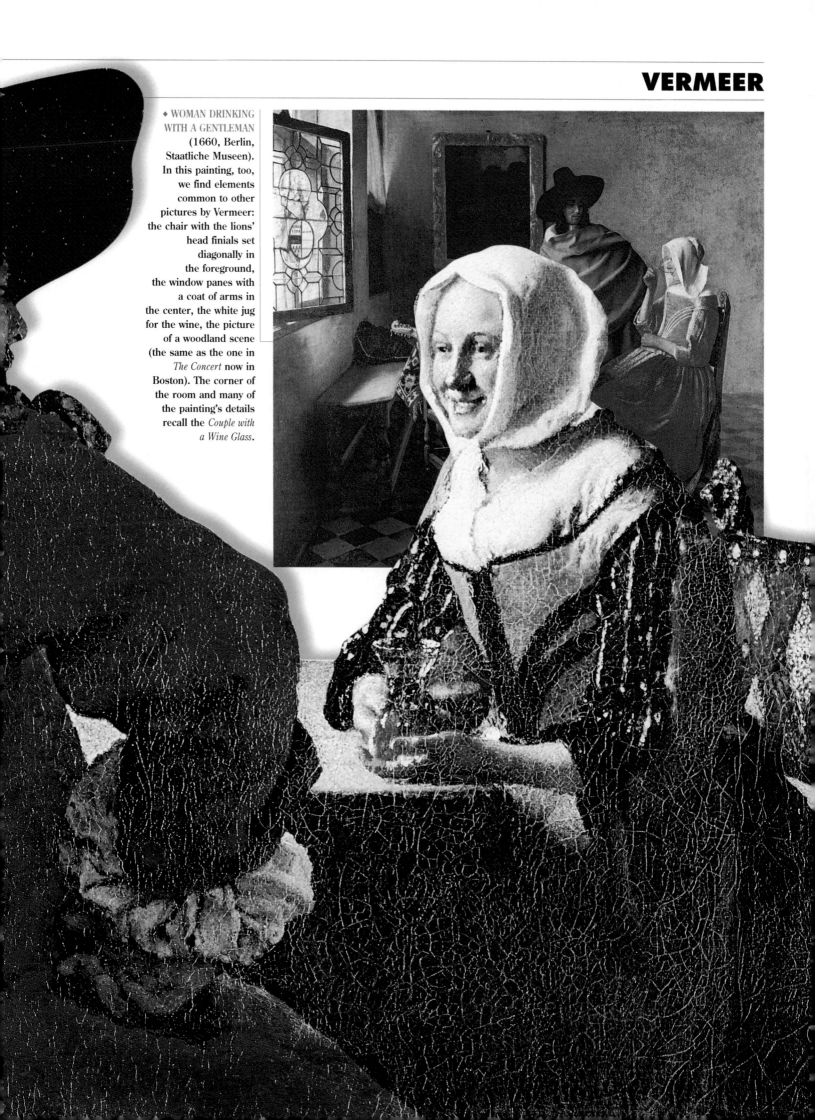

♦ WOMAN DRINKING WITH A GENTLEMAN (1660, Berlin, Staatliche Museen). In this painting, too, we find elements common to other pictures by Vermeer: the chair with the lions' head finials set diagonally in the foreground, the window panes with a coat of arms in the center, the white jug for the wine, the picture of a woodland scene (the same as the one in *The Concert* now in Boston). The corner of the room and many of the painting's details recall the *Couple with a Wine Glass*.

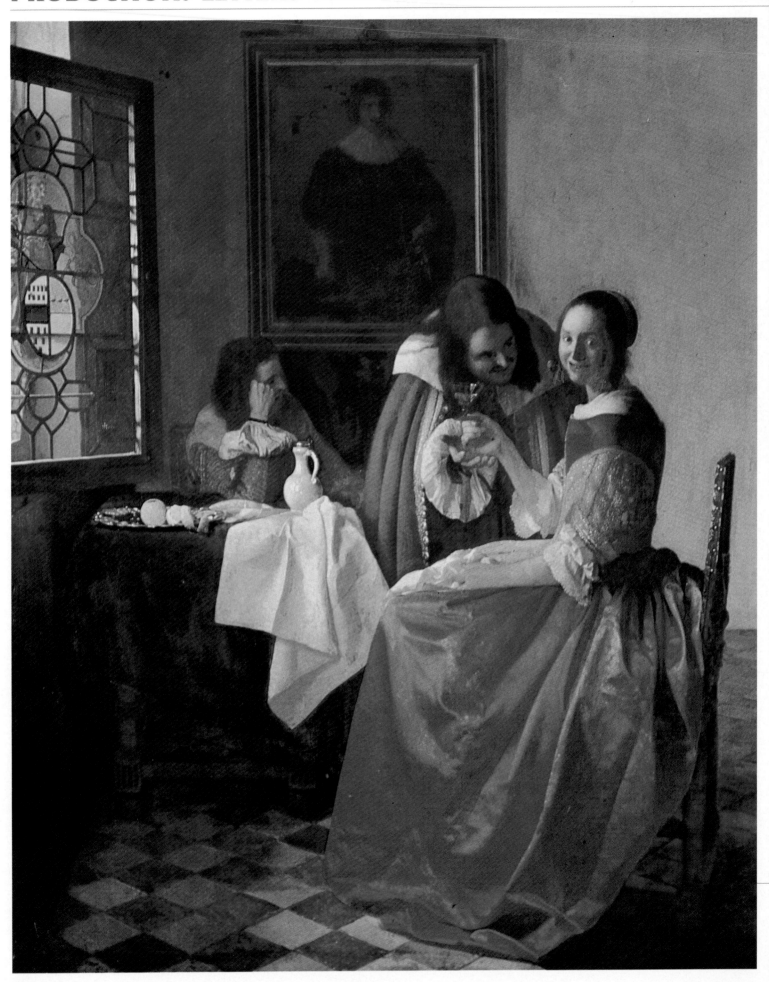

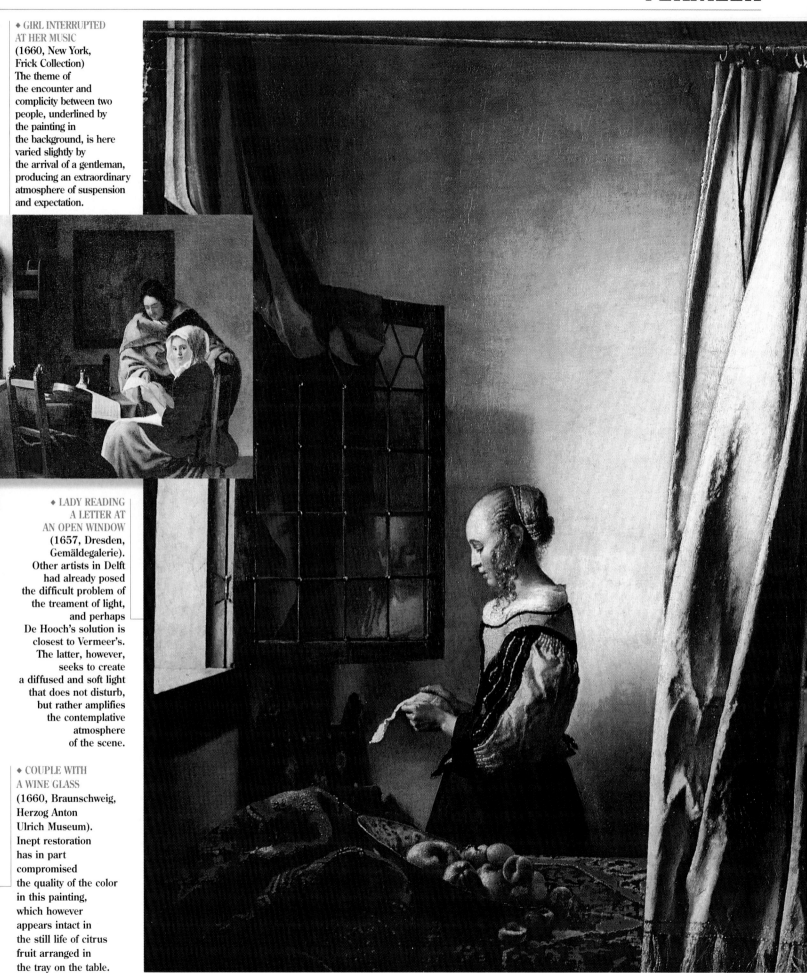

◆ GIRL INTERRUPTED
AT HER MUSIC
(1660, New York,
Frick Collection)
The theme of
the encounter and
complicity between two
people, underlined by
the painting in
the background, is here
varied slightly by
the arrival of a gentleman,
producing an extraordinary
atmosphere of suspension
and expectation.

◆ LADY READING
A LETTER AT
AN OPEN WINDOW
(1657, Dresden,
Gemäldegalerie).
Other artists in Delft
had already posed
the difficult problem of
the treament of light,
and perhaps
De Hooch's solution is
closest to Vermeer's.
The latter, however,
seeks to create
a diffused and soft light
that does not disturb,
but rather amplifies
the contemplative
atmosphere
of the scene.

◆ COUPLE WITH
A WINE GLASS
(1660, Braunschweig,
Herzog Anton
Ulrich Museum).
Inept restoration
has in part
compromised
the quality of the color
in this painting,
which however
appears intact in
the still life of citrus
fruit arranged in
the tray on the table.

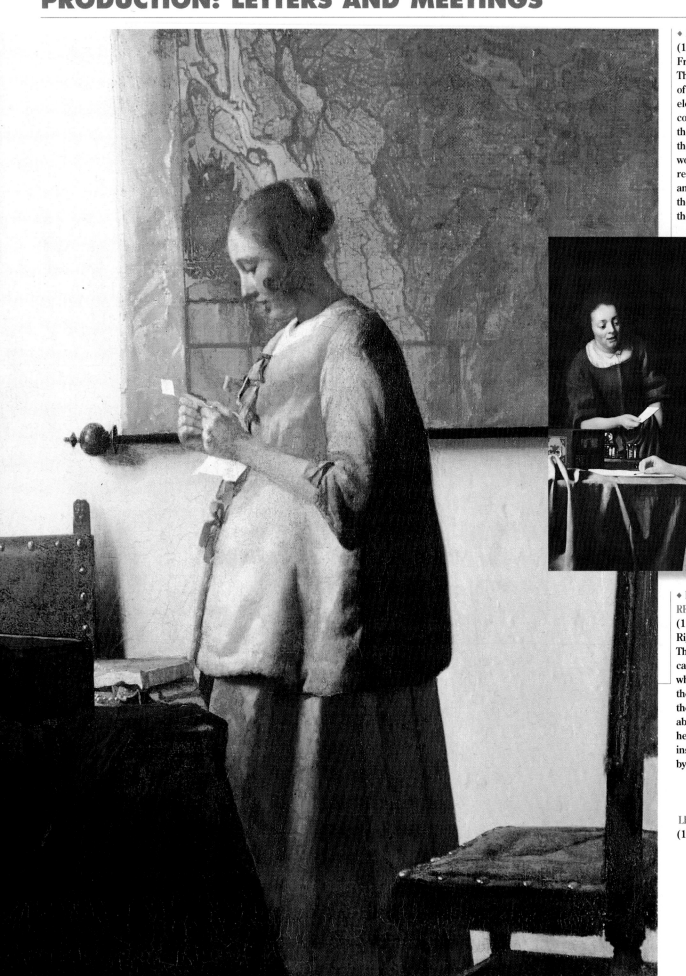

◆ MISTRESS AND MAID (1666-67, New York, Frick Collection). This is a painting of great beauty and elegance, for its compositional unity and the skill with which the profile of the young woman has been rendered. The power and harmony of the colors model the forms in full light.

◆ LADY IN BLUE READING A LETTER (1662-65, Amsterdam, Rijksmuseum). The soft, diffused light caresses the woman, who stands out against the map in the background, silently absorbed in reading her letter: an intense instant, uninterrupted by any noise.

◆ LADY WRITING A LETTER WITH HER MAID (1670, Dublin, National Library of Ireland). Another scene created by light and shadow highlights the solid figure of the maid waiting behind a radiant woman intent on her writing.

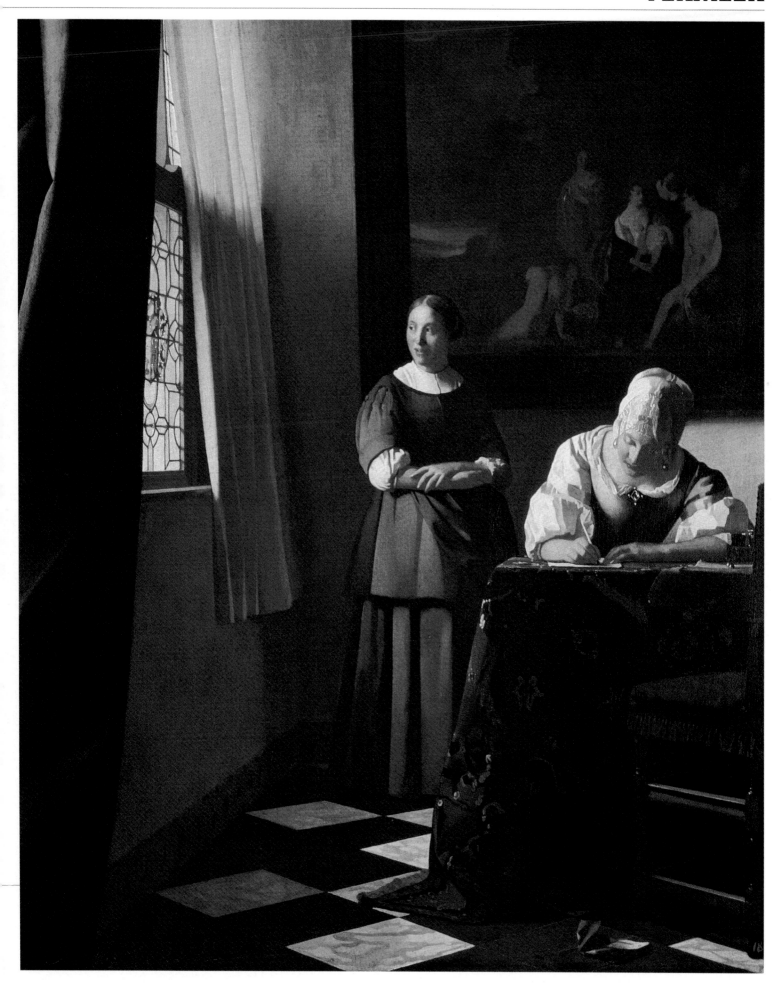

VIEWS OF THE CITY

Vermeer's preference went to subjects that were part of his everyday world; interiors, maps, globes, pictures hanging in his house which he reproduced faithfully again and again, people wearing their usual clothes, household furnishings. His painterly sensibility found expression above all in small, intimate, closed spaces. His city, too, was part of his representation of the reality surrounding him.

● Unfortunately, only two landscape paintings have reached us: one is a broad view of Delft, the other depicts a typical little street in the town, with its houses, shops, and people busy about their daily tasks. Naturally, he may have painted others which have not survived or are as yet undiscovered.

◆ VIEW OF DELFT (1661, The Hague, Mauritshuis). This painting is a true masterpiece. The painter, who specialized mainly in interiors, only rarely worked on exterior scenes. Thus it is astonishing to see his skill and the stroke of genius in his choice of viewing point, his compositional strategy, and finally the quality of the light, sharp and crystal-clear, capable of intensifying the colors and creating highlights and effects of transparence.

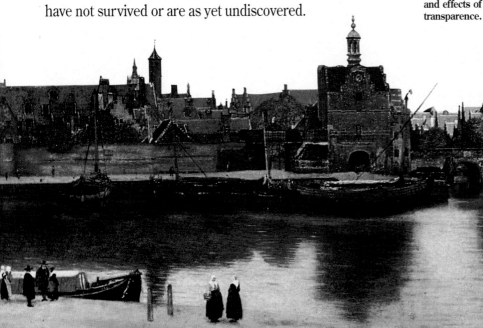

● Vermeer tended to go beyond the conventions of his time for landscape painting: in this area as well, he applied his own personal realism, altering and forcing here and there the reproduction of reality, creating special effects to enhance the optical illusion and the impression of reality. Sometimes he even altered perspective slightly to diminish the three-dimensionality of the scene and emphasize its frontality.

● The leading Dutch scenic painters of the period were Pieter De Hooch, Egbert Van der Poel, and Daniel Vosmaer for exteriors, and Emmanuel De Witte for interiors, particularly of churches.

◆ STREET IN DELFT (1661, Amsterdam, Rijksmuseum). Some scholars hypothesize that the characteristic street scene on the facing page could represent the little alley where the headquarters of the Guild of St Luke was located; we have no way of knowing. The painter succeeds in making even the building materials, the uneven roofs, the typical red color of the bricks of Delft glow with light.

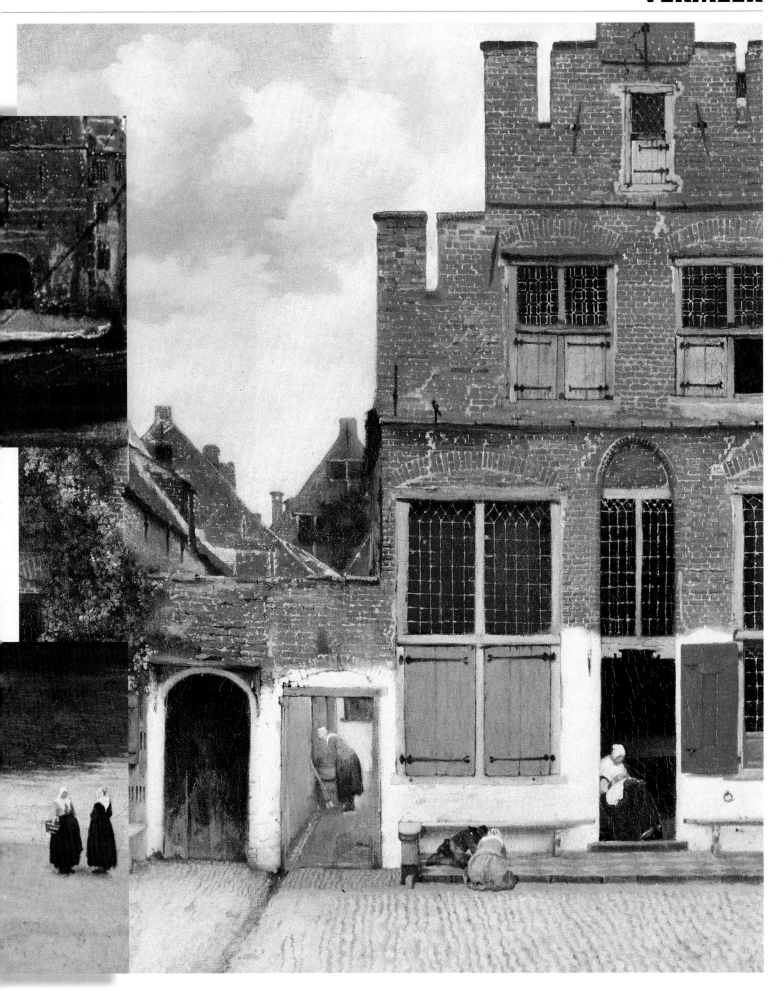

TRUTH, FAITH, ART

The simplicity of the gestures and the naturalness of the scenes in Vermeer's paintings must not deceive the viewer into thinking they are easy to interpret. The artist's continual recourse to emblems and iconology renders their reading highly complex.

● The woman represented with scales in hand, commonly known as *A Lady Weighing Gold* (or *Pearls*), on closer examination appears to be a representation of Truth, keeping in mind that scales are an emblem of justice and thus of truth, that a painting of *The Last Judgment* hangs behind the woman, and that in Cesare Ripa's treatise on *Iconology* – already circulating among Dutch artists in translation since 1644 – Divine Justice holds scales for weighing human events.

● Complicating things even further is the fact that Vermeer, even though he loved to use symbolic and iconological figurative elements, reinterpreted in his own way and to suit his own purposes the attributes of the personification of certain concepts, using some and discarding or adding others. Thus in *The Allegory of Faith* some symbols are included but not in their currently accepted meaning, others are completely missing, and the prescribed *Sacrifice of Isaac* is substituted by a *Crucifixion* by Jordaens.

● *The Allegory of the Art of Painting* represents the painter's studio as he depicts Fame, perhaps placing it in relationship, through symbols scattered everywhere (mask, trumpet, musical score, book), with Music and Drama. The young woman could however also represent Clio, the Muse of History (she too wears a laurel crown), proclaiming the glory of the winner.

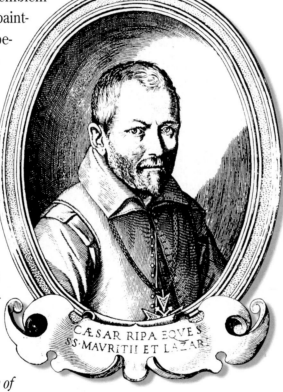

◆ PORTRAIT OF CESARE RIPA His *Iconology* was required reading in the 17th century for understanding the symbols in allegories. This portrait was included in the 1618 edition, on the page facing the Preface.

CÆSAR RIPA EQVES SS·MAVRITII ET LAZARI

◆ A LADY WEIGHING GOLD (OR PEARLS) (1665, Washington, National Gallery of Art). The *Last Judgment* hanging on the wall in the background reinforces the allegorical significance of the painting. The woman, noticeably pregnant, holding the scales with which she is weighing gold and pearls, represents the image of truth and justice, of which the scales are the usual attribute.

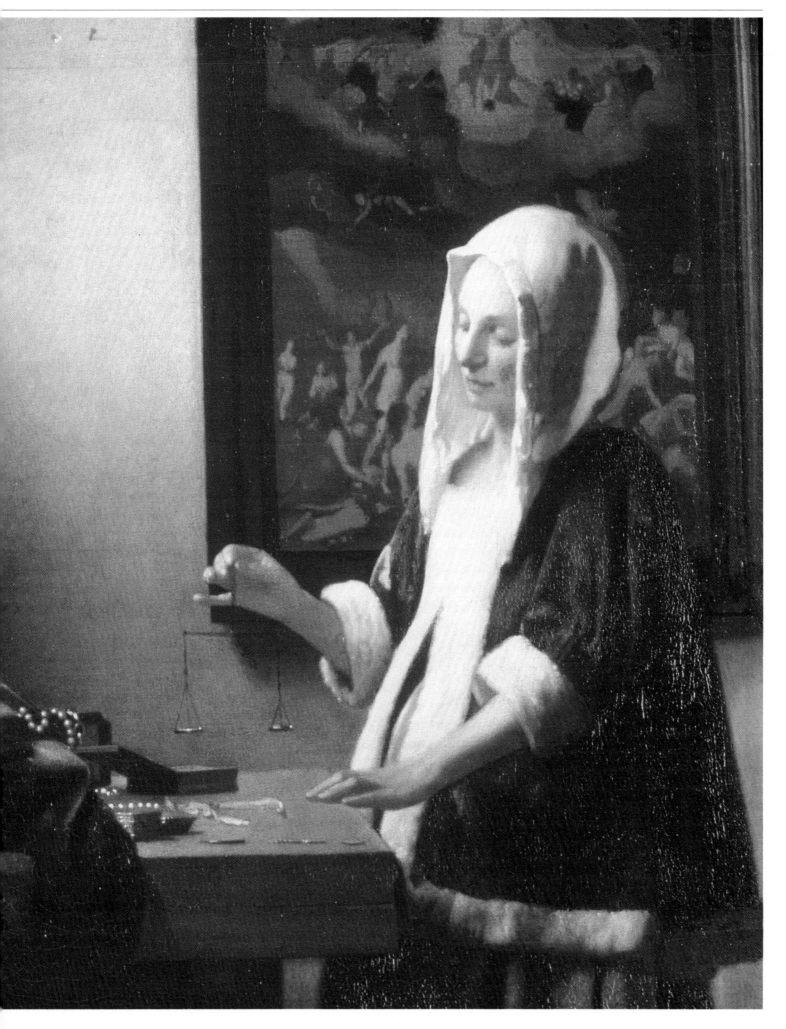

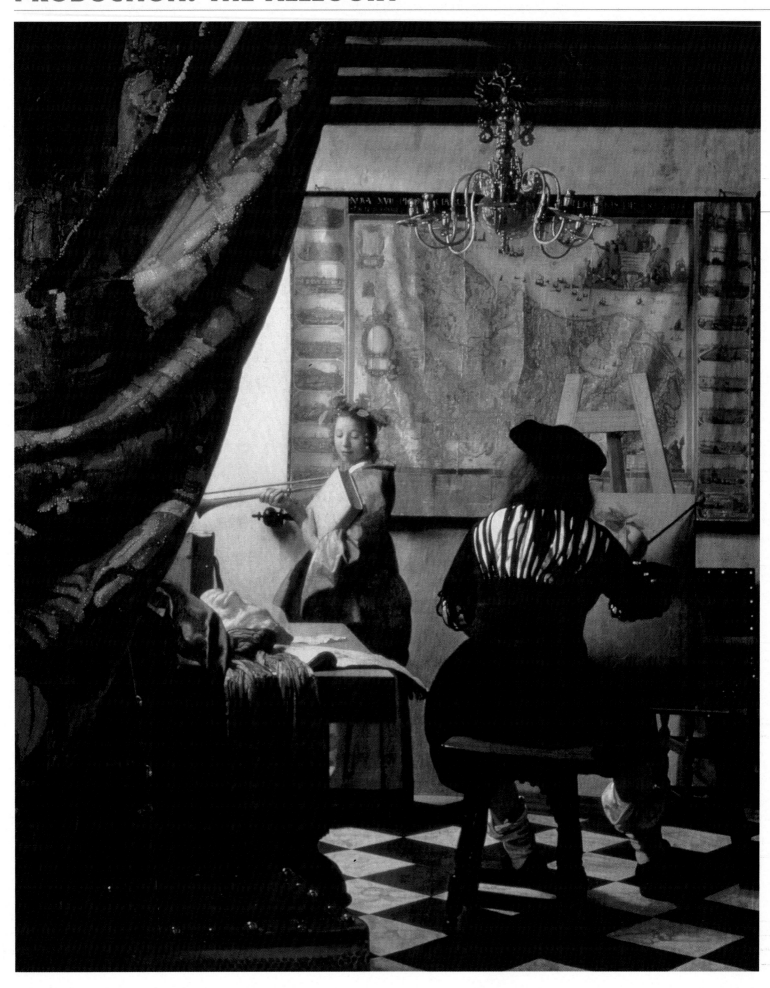

◆ THE ALLEGORY OF
THE ART OF PAINTING
(1662-65, Vienna,
Kunsthistorisches
Museum).
The painter is in his
studio, intent on
painting his model; he
wears the same clothes
as the figure looking at
the observer in
The Procuress. The map
reproduced on the back
wall was drawn up
by Nicolaes Visscher
and represents
the Netherlands.
The young girl holding
a trombone represents
Fame, but she could
also be Clio, Muse of
History, confirming
the painter's glory.

◆ THE ALLEGORY
OF FAITH
(1670, New York,
Metropolitan Museum).
The rendering
of details in this
painting is remarkable,
from the glass globe
hanging by a blue
ribbon (whose
symbolism is difficult
to interpret) to
the curtain glowing
with flecks of light, from
the chalice to
the crushed snake,
from the apple to
the crucifix. Faith is
shown according to her
description in Ripa's
Iconologia: a seated
woman resting her foot
on a celestial globe.
Here she is dressed in
white and blue rather
than blue and red.

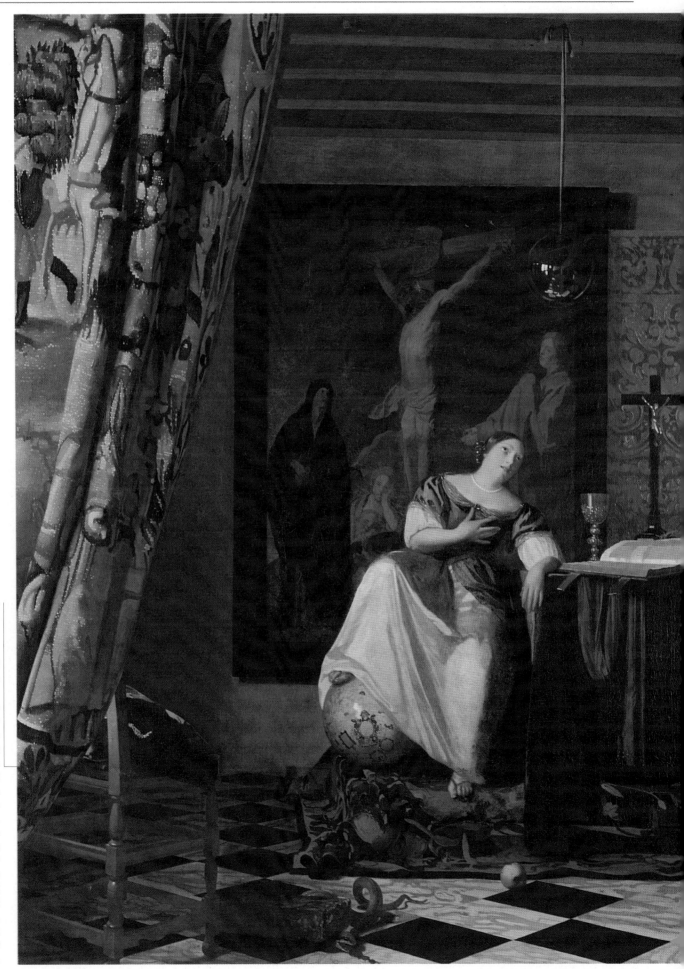

THE PAINTING WITHIN THE PAINTING

The custom of using a "painting within painting" in the depiction of interiors in Dutch seventeenth century painting is not characteristic only of Vermeer, but his use of it is completely his own. The pictures he reproduces serve not only to help give a meticulous description of the environment, but they have the function of reinforcing the scene's meaning: they set up a relationship with the persons present, facilitating interpretation of the whole.

● Dirck Van Baburen's *The Procuress* appears in *The Concert* and in *A Lady Seated at a Virginal*. In the first, it seems to call attention to the risks that can come from music's excesses.

● The theme of "Roman Charity" – Pero feeding her imprisoned father Cymo from her breast – appears in the Caravaggesque painting in the background of the room where *The Music Lesson* is taking place, in which the painter himself also appears, watching his daughter play. The painting seems to suggest that the artist, like Cymo, takes nourishment and comfort from the music made by his daughter.

● Other iconographical elements appear quite regularly in Vermeer's paintings. As the inventory made after his death indicates, these are objects that were actually in his house: musical instruments, the white jug with a stopper (we see it again in *Girl Asleep, Two Gentleman and a Woman with a Glass of Wine, The Music Lesson, Woman Drinking with a Gentleman*), globes and maps – rendered so precisely as to be able to identify the original – and, last but certainly not least, the yellow jacket edged with ermine.

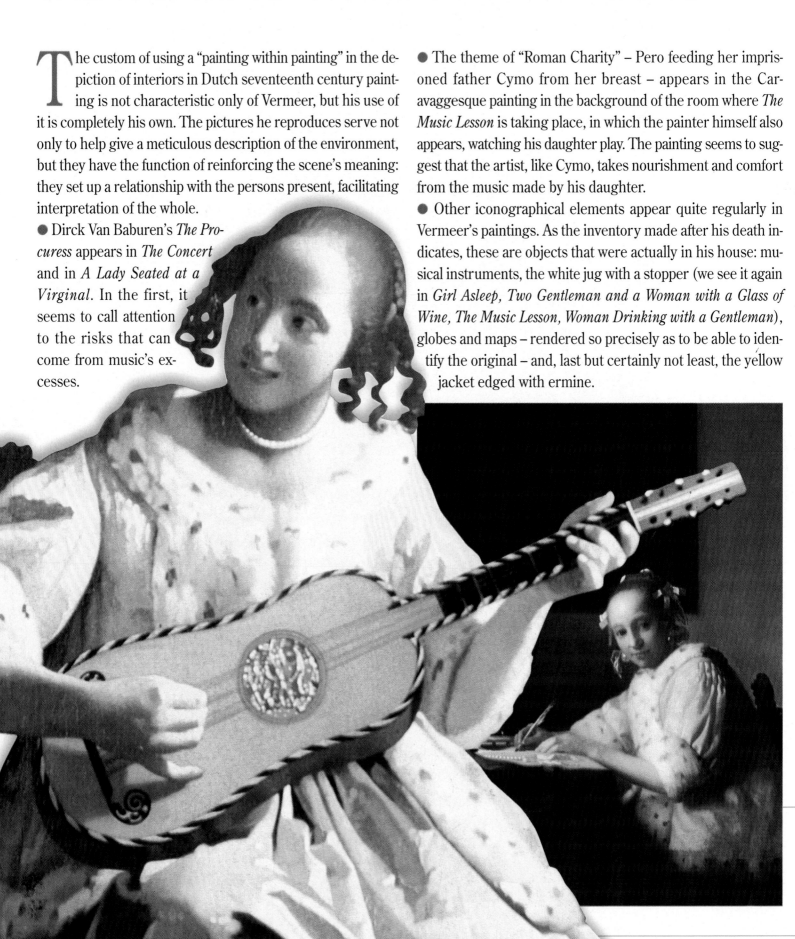

Some scholars feel
that this painting could
be the *pendant* to
The Music Lesson,
but the measurements
do not coincide.
The painting hanging
on the wall on the right
is the famous
The Procuress by
Dirck Van Baburen,
dated and signed 1622
and actually belonging
to the Vermeer family,
as we learn from
the inventory taken
after the artist's death;
this painting is now
in the Museum
of Fine Arts in Boston.
A cello is lying on
the black and white
marble tiled floor,
while a lyre lies
on the table.

◆ A LADY WRITING
(1665, Washington,
National Gallery of Art).
The masterfully
contrasting blues and
yellows heighten
the brightness
and diffused glow
of the scene.
This painting, which
is in excellent condition,
allows us to study in
depth the technique
Vermeer used
to light up his surfaces.
The ribbons in the girl's
hair work toward
the same end.
On the wall
behind her hangs
a still life
of musical instruments.
The yellow
ermine-trimmed
jacket appears
in five other paintings:
*Lady with a
String of Pearls,
Mistress and Maid,
The Love Letter,
The Guitar Player,
The Lute Player.*

◆ THE GUITAR PLAYER
(1667, London,
Kenwood House).
This girl is one
of the few smiling
figures depicted by
the master.
Her yellow jacket
here drapes richly
and the guitar is
reproduced with
astonishing fidelity,
even down to its double
strings, the custom
in the seventeenth
century.

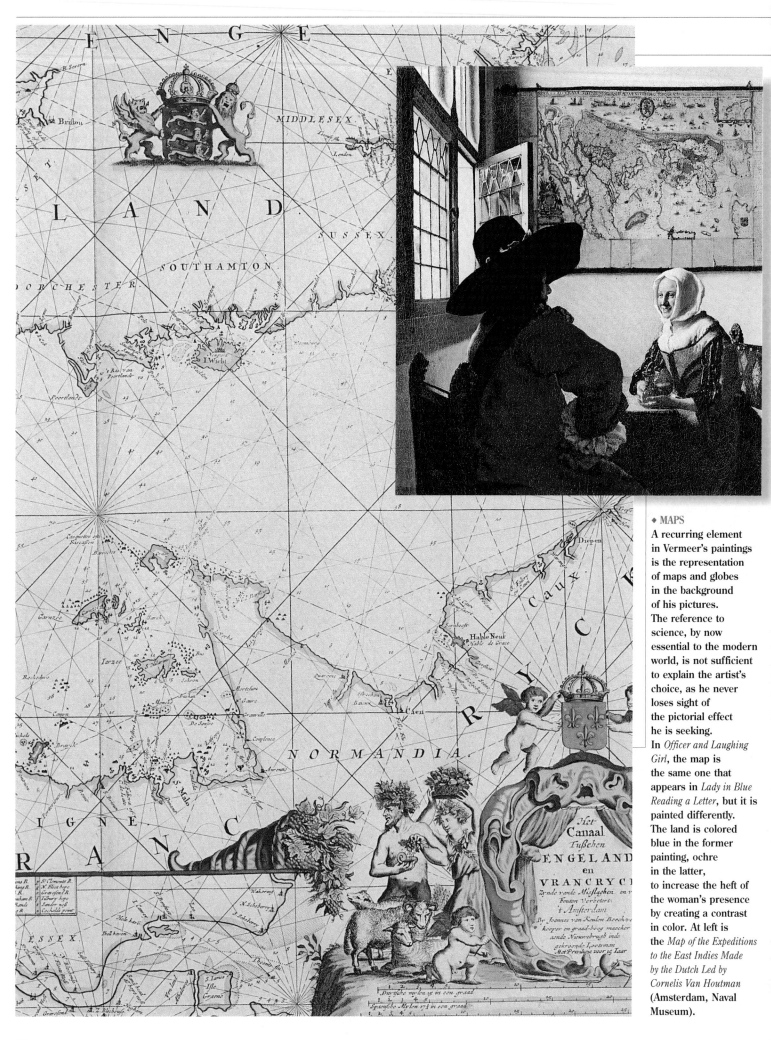

◆ MAPS

A recurring element
in Vermeer's paintings
is the representation
of maps and globes
in the background
of his pictures.
The reference to
science, by now
essential to the modern
world, is not sufficient
to explain the artist's
choice, as he never
loses sight of
the pictorial effect
he is seeking.
In *Officer and Laughing
Girl*, the map is
the same one that
appears in *Lady in Blue
Reading a Letter*, but it is
painted differently.
The land is colored
blue in the former
painting, ochre
in the latter,
to increase the heft of
the woman's presence
by creating a contrast
in color. At left is
the *Map of the Expeditions
to the East Indies Made
by the Dutch Led by
Cornelis Van Houtman*
(Amsterdam, Naval
Museum).

◆ **A RECURRENT MOTIF: THE JUG**
The Music Lesson (1664, London, Buckingham Palace) shows a large number of the recurrent motifs in Vermeer's paintings and some curious coincidences. First of all, the white jug, which appears mainly in pictures expressing the idea of an amorous encounter, and seals the bond established between the figures represented. Here the connection is made by the fact that the man leaning on his stick is perhaps the girl's father. Notice that the father's physical appearance recalls that of the *Astronomer* and the *Geographer*, which are probably Vermeer's self-portraits.

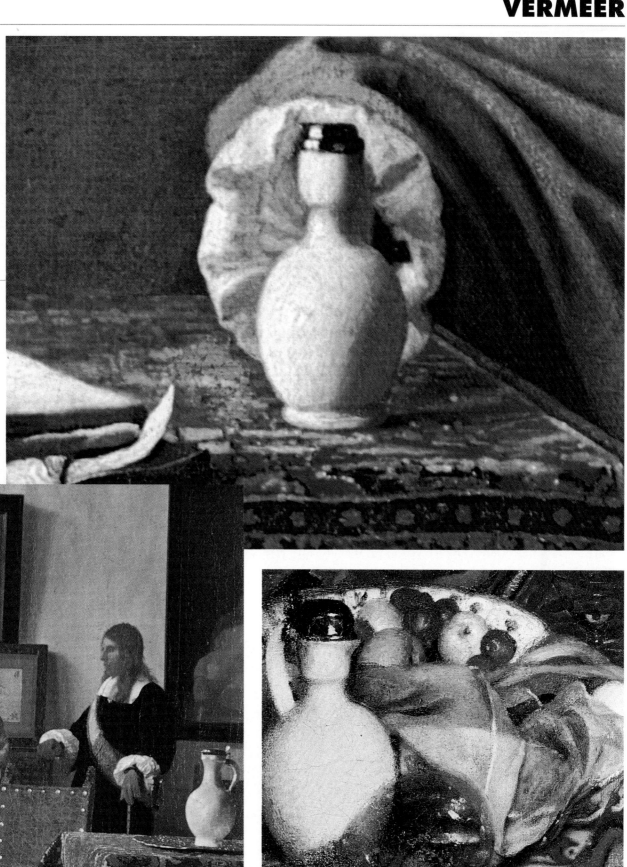

FAKES AND DOUBTS

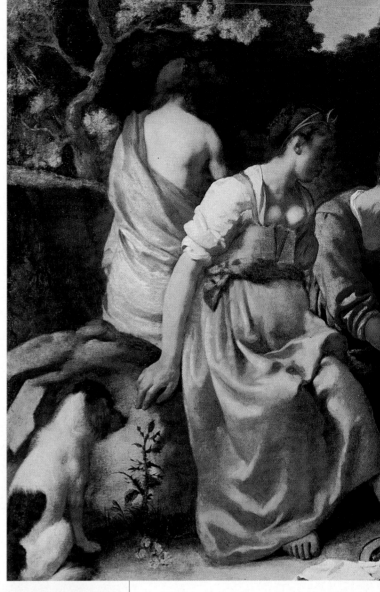

Vermeer's critical success has come about only quite recently, and thus his entire *corpus* for years, in fact for centuries, fell into oblivion. The first studies made of his work date to the second half of the nineteenth century, and since then great efforts have been made to reconstruct a catalogue *raisonné*, with the greatest difficulty being to identify his earliest works, which differ from the others in style and theme. The *corpus* of certain works that has been established is quite limited, and includes fewer than fifty paintings.

● Naturally, this situation was an easy one for counterfeiters and unscrupulous dealers to exploit. One of them, Han Anthonius Van Meegeren, a painter, caused a real sensation during the years of the Second World War. Gifted with great technical skill and a good knowledge of pigment chemistry, he specialized in the counterfeiting of Vermeer paintings. He made some profitable sales, but when he was accused of collaborating with the enemy for having sold a "Vermeer" to the Nazis, he defended himself by confessing his deception. The court resisted believing him, and only after he gave public proof of his ability to execute a fake was it convinced that he was now telling the truth. Naturally, this episode caused enormous turmoil both in the academic world and in the art market, which had supported him in good faith.

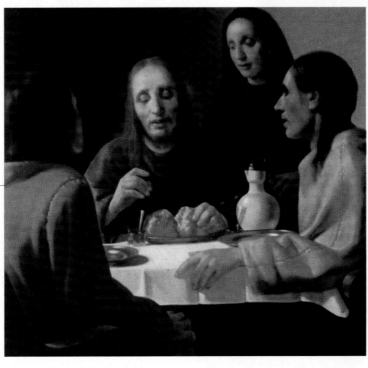

◆ HAN ANTHONIUS VAN MEEGEREN
Supper at Emmaus
(1936-37, Rotterdam, Museum Boymans-Van Beuningen).
Van Meegeren took advantage of the fact that little information is available about Vermeer's early activity (it is thought that this consists mainly of religious paintings) to orient his counterfeiting in this direction. His works were accredited by respected critics who, in good faith, fell into his trap.

◆ DIANA AND HER COMPANIONS
(c. 1654, The Hague, Mauritshuis).
This is Vermeer's only canvas on a mythological subject, strongly influenced by a similar painting by Jacob Van Loo. A nymph takes care of the goddess by washing her feet in a silent and solemn ritual, while the other nymphs appear immobile or suspended in action. Even the dog sits calmly and quietly. The quiet atmosphere exuded by the scene is suggested by the absence of dialogue between the glances: all the nymphs look at the ground.

◆ CHRIST IN THE HOUSE OF MARY AND MARTHA
(c. 1654, Edinburgh, National Gallery of Scotland).
The work belongs to the period of the artist's formation, when he painted sacred subjects. The Gospel episode is recounted in Luke 10:38. Mary is seated on this side of the table, at Christ's feet, listening to his words. Martha, busy at her housework, approaches him to ask him a question and to urge him to have Mary help her. The painting has been compared, for its dense brushstroke, to the work of the Caravaggesque Terbrugghen, and in the handling of the drapery to Jacob Van Loo.

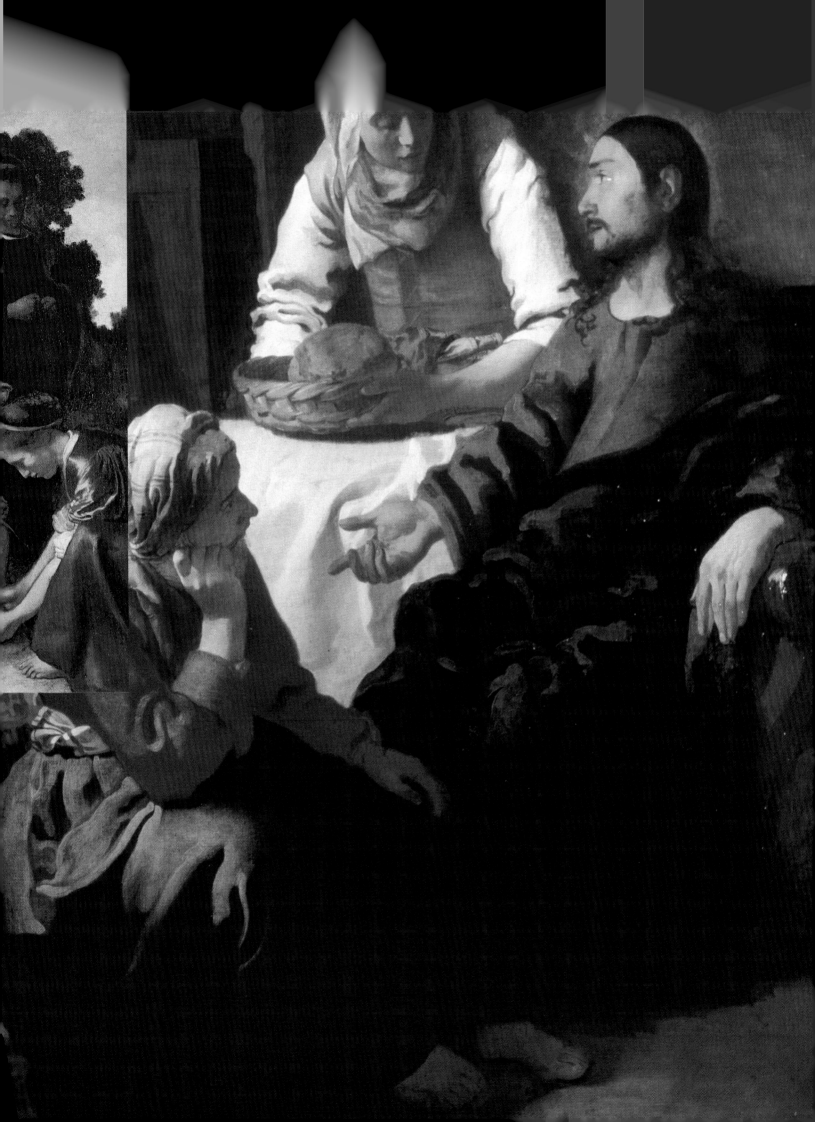

SCIENCE AND BUSINESS

I n the seventeenth century, Dutch economic power reached its zenith, as Holland traded on a world-wide scale. The East India Company replaced Portugal as leader in the spice trade, while the West India Company was present both in North America (where it founded New Amsterdam, the future New York) and in South America, where it ran a slave trade.

● Above and beyond their internal political and religious problems, the Dutch had necessarily to adapt to the heterogeneous multitude which crowded into their large economic centers, and they could not give in to prejudices which in the end were only bad for business. Baruch Spinoza claimed for man freedom of thought and civil rights, theorizing the concept of democracy.

● Studies of the applied sciences were lively, thanks to observations made using the experimental method; botany and zoology were given a modern classification, and chemistry took the place of Renaissance alchemy.

● Kepler, the student of Tycho Brahe, spelled out the laws of the motion of planets and demonstrated that their orbits are elliptical, not circular. Descartes found in mathematics the methodological foundation for the investigation of nature.

● With Comenius, great impetus was given to the principle of universal education, and the publication and sale of books increased enormously. Newspapers and periodicals published in Amsterdam, Rotterdam, and Leiden grew ever more important.

◆ THE ASTROLABE
This is an instrument for observing and measuring the height of a heavenly body above the horizon. Above is an example of 1658, now in the Museo Navale in Pegli, in the province of Genoa; below, a nautical astrolabe of 1608, in the Museo di Storia della Scienza in Florence.

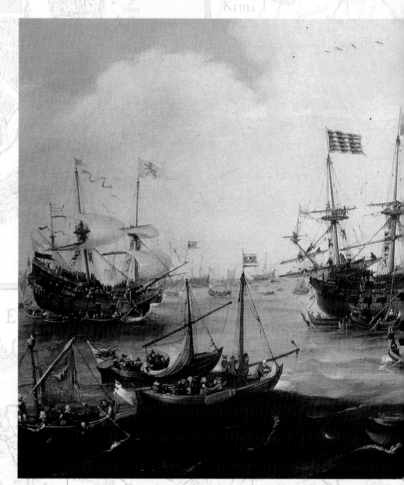

◆ ANDRIES VAN VEERTVELT
The Arrival in Amsterdam of Four Ships of the East India Company (c. 1624, Greenwich, Maritime National Museum).

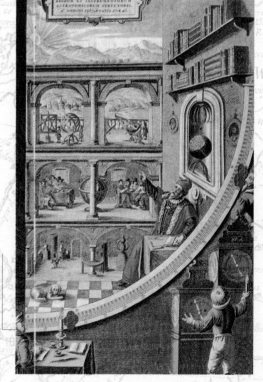

◆ THE OBSERVATORY OF TYCHO BRAHE
The engraving shows a detail of the interior of the famous observatory built at the end of the 16th century by Tycho Brahe.

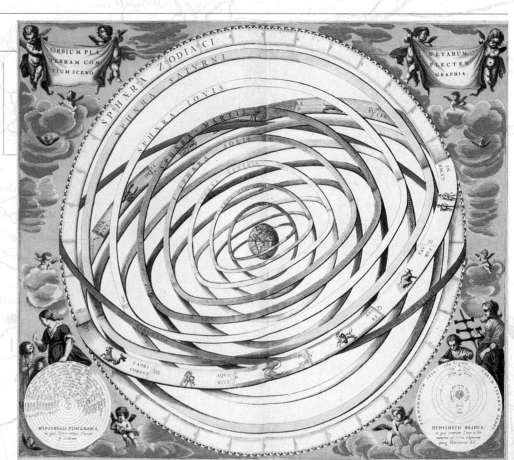

◆ ANDREAS CELLARIUS
The Planetary Orbits
The engraving represents the systems of Ptolemy and Tycho Brahe and is taken from the volume *Harmonia Macrocosmica*, published by Joannes Janssonius in Amsterdam in 1660-61.

◆ JACOB GERRITSZ
Portrait of Abel Janszoon Tasman with his Wife and Daughter
(1637, Canberra, National Library of Australia).
The Dutch navigator discovered Tasmania during his endless voyages.

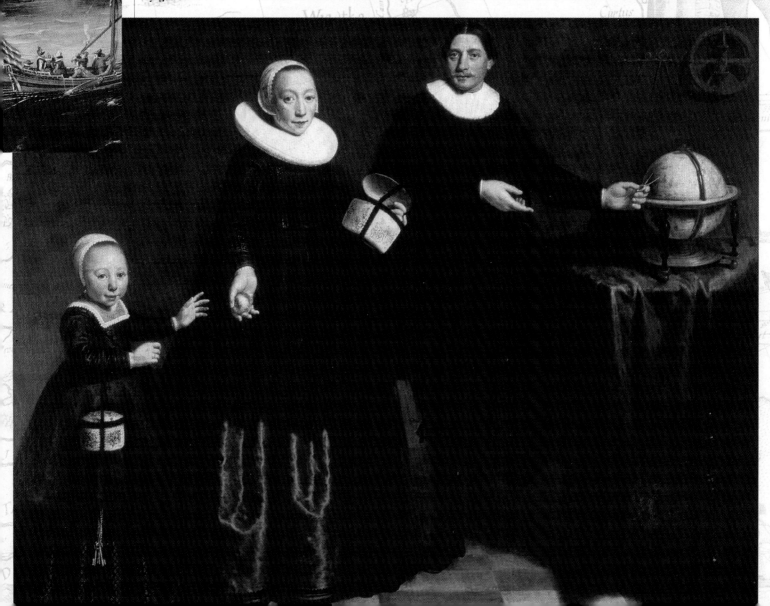

GENRE PAINTING

As had already happened for Rembrandt, who was set aside in the space of two decades, also for Vermeer serious research into his work had to wait until the nineteenth century. But while Rembrandt had already had during his life a large group of students to whom to teach the secrets of his art, the same was not true for Vermeer, who stands alone in his original allegorical interpretation of the prevailing category of genre painting.

● Historical and social conditions in Holland favored to various degrees the affirmation of an art with secular subjects, portraying merry company or people occupied serenely in their work, gratified by a hospitable and welcoming land where everyone lived in harmony and had time to appreciate the simplicity of small everyday gestures.

● The art of Vermeer only apparently fits into this vein: it does not stop at fixing on canvas a gesture, a typical scene, a domestic occupation, but seeks the harmony governing human relationships, freezes a split second of time so as to communicate a sense of waiting, and invites the observer to go beyond reality's appearances.

● For these reasons, it sometimes seems reductive to place the work of the Master of Delft in relationship with that of artists like Pieter De Hooch, Gerard Ter Borch, Jan Steen, Frans Van Mieris, Gabriel Metsu, Caspar Netscher, or Emmanuel De Witte. Despite similarities of subject, there are significant differences in the handling of color, space, and light, which bring Vermeer's artistic development much closer to our modern sensibility.

◆ PIETER DE HOOCH
Music in the Courtyard
(c. 1677, London, National Gallery).
Not only the daily life of the lower classes but also that of the burghers is depicted in genre painting.

◆ JAN STEEN
The World Turned Upside Down
(c. 1663, Vienna, Kunsthistorisches Museum).

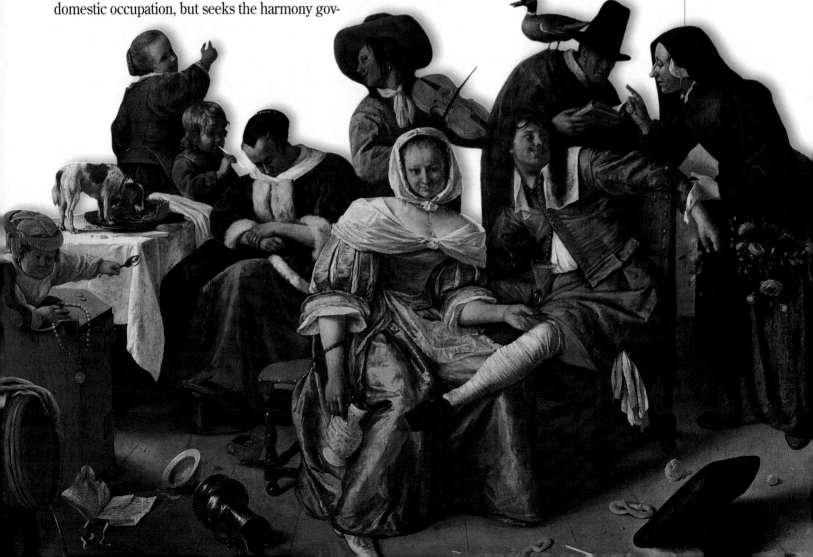

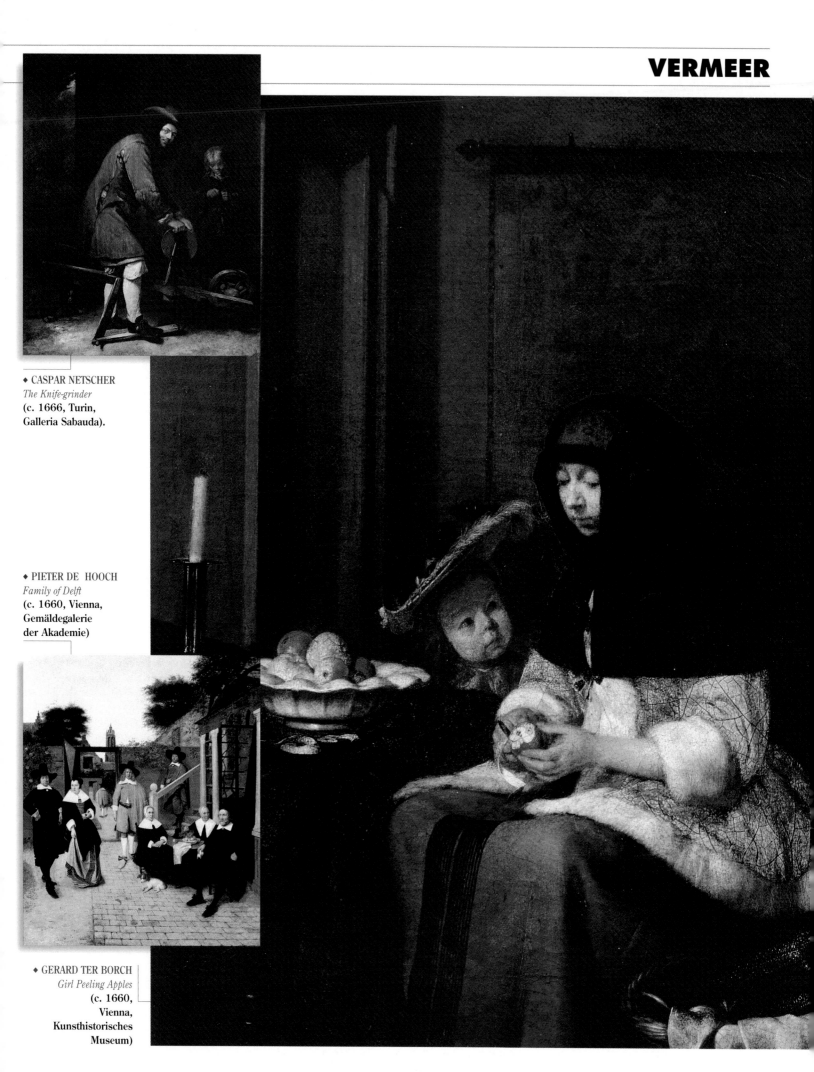

◆ CASPAR NETSCHER
The Knife-grinder
(c. 1666, Turin,
Galleria Sabauda).

◆ PIETER DE HOOCH
Family of Delft
(c. 1660, Vienna,
Gemäldegalerie
der Akademie)

◆ GERARD TER BORCH
Girl Peeling Apples
(c. 1660,
Vienna,
Kunsthistorisches
Museum)

THE ARTISTIC JOURNEY

For a insight into the whole of Vermeer's production,
we have compiled a chronological summary of his principal works

◆ CHRIST IN THE HOUSE OF MARY AND MARTHA (c. 1654)

The Gospel episode is recounted in Luke 10:38. Mary is seated on this side of the table, at Christ's feet, listening to his words. Martha, busy at her housework, approaches to ask him a question and to urge him to have Mary help her. The painting has been compared, for its dense brushstroke, to the work of the Caravaggesque Terbrugghen, and in the handling of the drapery to Jacob Van Loo.

◆ THE PROCURESS (c. 1656)

The subject was inspired by the analogous painting by Dirck Van Baburen in the house of Maria Thins, Vermeer's mother-in-law. The differences between the two paintings are enormous, both from the compositional and aesthetic points of view; the only element they have in common is the gesture of the man holding out a coin. On the left is a probable self-portrait of the artist, looking out knowingly at the viewer.

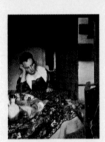

◆ GIRL ASLEEP (c. 1657)

Intense tones of red and yellow link this picture with the preceding one, as does the bright tablecloth in the foreground. But here a strict organization of the space begins to be manifest, with the attention focused on the middle plane where the main scene is set. Thus the rest of the painting, although meticulously described, does not distract the viewer's eye from the painting's subject.

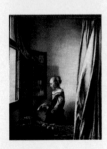

◆ LADY READING A LETTER AT AN OPEN WINDOW (1657)

This painting, along with the next, marks a turning point in the artist's handling of light. Other artists in Delft had dealt with this difficult problem, and perhaps the solution found by De Hooch is closest to Vermeer's. The latter, however, seeks to render a soft, diffused light that does not disturb, but rather enhances, the contemplative atmosphere of the scene.

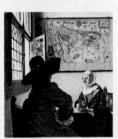

◆ OFFICER AND LAUGHING GIRL (c. 1657)

The light streams through the window and spreads through the room much more brightly than in the picture above, painted roughly at the same time. A contrast is set up between the figure of the soldier in the foreground, placed diagonally and in shadow, and the laughing girl sitting in full sunlight and holding a glass of wine in her hands. A map of Holland and Friesland on the wall frames the scene from the back, while a table creates the space between them.

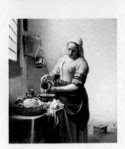

◆ THE KITCHEN MAID (1658-60)

The woman, surrounded by household objects in daily use, is immersed in natural light. The painter sprinkles glowing flecks of white paint on the maid's dress, the bread, the shining containers, the dishes. The rarefied light, the tactile quality of the objects, and the delicate play of light and shade lift this picture far above genre painting.

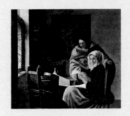

◆ GIRL INTERRUPTED AT HER MUSIC (1660)

The painting is currently in a state of conservation that suffers from inept restorations and frequent changes of ownership. But the quality has not been compromised so badly that the very fine elements it shares with other similar paintings cannot be seen. On the wall in the background hangs the same painting included in *Lady Standing at a Virginal*, i.e. a *Love Triumphant*, probably by Van Everdingen.

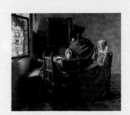

◆ WOMAN DRINKING WITH A GENTLEMAN (1660)

Here too we find elements in common with other paintings by Vermeer: the foreshortened chair in the foreground, the window with the coat of arms in the center, the wine jug, the painting of a woodland (the same which appears in *The Concert* in Boston). The corner of the room depicted here recalls the setting of *Couple with a Wine Glass*.

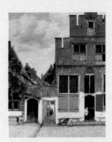

◆ STREET IN DELFT (1661)

In a rare representation of a view, Vermeer paints a corner of the city where he lives. Some scholars hypothesize that this could be the little alley where the headquarters of the Guild of St. Luke was located; we have no way of knowing. What is interesting here is the way the painter renders the building materials, uneven roofs, the typical red of the bricks of Delft, and, as always, women going about their womanly tasks.

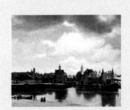

◆ VIEW OF DELFT (1661)

This painting is a true masterpiece, especially considering the fact that the artist painted essentially interiors and only rarely did landscapes. Thus his mastery and genius are particularly astonishing in his choice of a viewing point, his compositional strategy, and finally, the quality of the limpid, crystalline light which enhances the colors and creates reflections and effects of transparency.

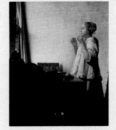

◆ LADY WITH A STRING OF PEARLS (1662)

The young woman looking at herself in the mirror, holding up for a better view the string of pearls around her neck, wears the yellow fur-trimmed jacket which appears in six of Vermeer's paintings. The luminous figure stands out against the bare wall, while the objects in the foreground seem to be immersed into an accentuated half-shade, broken by the chair set diagonally in the full light.

◆ THE ALLEGORY OF THE ART OF PAINTING (1662-65)

The painter is in his studio, intent on painting a model; he wears the same clothes as the figure looking at the spectator in *The Procuress*. The map hanging on the back wall is by Nicolaes Visscher and is of the Low Countries. The girl with a trombone symbolizes Fame, but she could also represent Clio, the Muse of History, confirming the painter's glory.

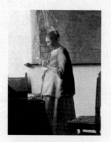

◆ LADY IN BLUE READING
A LETTER (1662-65)
The soft, diffused light caresses the woman who is silently absorbed in reading a letter; this is an intense moment, uninterrupted by any noise. The objects are meticulously described: the table covered by a cloth, the chairs upholstered in blue, the books on the table, the blue jacket worn by the woman standing out against the map in the background.

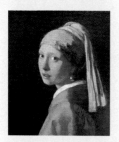

◆ THE MUSIC LESSON (1664)
The setting of this painting is very similar to the one seen in *The Concert*. The graceful, immobile figures are immersed in the silence of the instant in both paintings. The man leaning on a stick, rapt in the music played by the young girl, is perhaps her father. His physiognomy recalls that of *The Astronomer* and *The Geographer*, which are probably self-portraits.

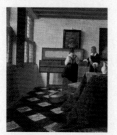

◆ GIRL IN A TURBAN (1664-65)
Some scholars have seen in this young girl one of Vermeer's daughters, perhaps the youngest. The date of the painting, according to various hypotheses, could be moved even earlier, or as late as 1672-73. But the technical characteristics of the painting place it, for most scholars, in the mid-1660s. The girl's exotic headdress appears in the inventory made after Vermeer's death.

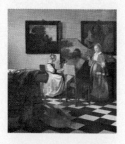

◆ A LADY WRITING (1665)
The painting of a young girl seated at a table, lifting her head to look at the observer while she writes a letter, is in excellent condition and beautifully painted. The blues and yellows placed skillfully in contrast enhance the clarity and luminousness of the scene. On the back wall is a painting of a still life with musical instruments.

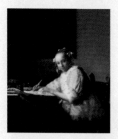

◆ A LADY WEIGHING GOLD (OR PEARLS) (1665)
The Last Judgment represented in the picture on the wall in the background reinforces the allegorical nature of the painting. The woman, noticeably pregnant, with her hand on the scales as she weighs the gold and pearls, is the image of Truth and Justice. The scales are the usual attribute of human Justice, but the theme of the painting hanging behind the woman points us toward a higher virtue.

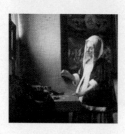

◆ THE CONCERT (1665-66)
Some scholars feel that this painting could be the *pendant* to *The Music Lesson*, but the measurements do not coincide. The painting hanging on the wall on the right is the famous *The Procuress* by Dirck Van Baburen, dated and signed 1622 and actually belonging to the Vermeer family. A cello is lying on the black and white marble tiled floor, while a lyre lies on the table.

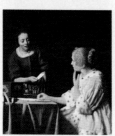

◆ MISTRESS AND MAID (1666-67)
This painting is one of extraordinary beauty and elegance both for its compositional unity and for the mastery with which the profile of the young woman is rendered. The power and harmony of the colors shape the forms as they are struck by the light. Once again we see the yellow ermine-trimmed jacket, and the jewel chest on the table is the same as the one in *A Lady Writing*.

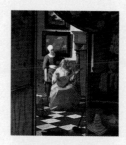

◆ THE LOVE LETTER (1667)
The structure of the painting seems quite complex, being divided into three planes in depth and vertically; the observer is on this side of the open door, the scene takes place on the other side, and on the back wall hang two landscapes, one above the other. The seated woman is richly dressed and wears jewels; in the left foreground is a map, on the right are musical scores.

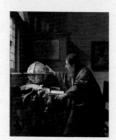

◆ THE ASTRONOMER (c. 1668)
Doubts as to the authenticity of the signature also make the date of the painting uncertain, but it is in any case one of the artist's finest works. Here too the details can be identified: a celestial globe by the Hondius family of mapmakers, and a painting of *Moses Saved from the Waters* probably by Jacob Van Loo. The astronomer could be a self-portrait of the painter himself.

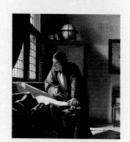

◆ THE GEOGRAPHER (c. 1669)
Thought for years to be the *pendant* of *The Astronomer*, *The Geographer* could in reality be a variant of the former. Supporting this thesis is the presence of a planetary sphere on top of the cupboard and the open map on the table, which seems to be more a map of the heavens than of the earth. The two paintings were often sold as a pair in auctions held in the first half of the eighteenth century in Amsterdam.

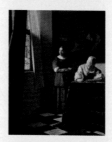

◆ LADY WRITING A LETTER WITH HER MAID (1670)
The "painting within the painting" is the same as the one in *The Astronomer*, but here it is shown larger. The maidservant stands behind her mistress, discreetly waiting while she finishes her letter. Once again, a reserved silence, but dense with feeling, prevails in this tranquil scene, which is played out without particular passion or drama.

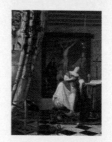

◆ LADY SEATED AT A VIRGINAL (1670)
The paired elements of a woman and music recur in Vermeer's work. The virginal shown here is with a few variations the same as the one in *The Music Lesson* and *Lady Standing at a Virginal* (even if the landscape painted on the cover is slightly different). The keyboard set on the right of the instrument is typical of the Low Countries, and a virginal of this description appears also in the inventory of Vermeer's property.

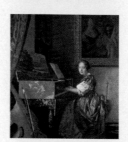

◆ THE ALLEGORY OF FAITH (1670)
The rendering of details is remarkable, from the glass globe hanging by a blue ribbon (whose symbolism is difficult to interpret) to the curtain glowing with flecks of light, from the chalice to the crushed snake, from the apple to the crucifix. Faith is shown as she is described in Ripa's *Iconology*: a seated woman resting her foot on a celestial globe, but here dressed in white and blue rather than blue and red.

◆ LADY STANDING AT A VIRGINAL (1671)
Some critics have seen in this painting signs of a decline on the part of the artist, who here seems more a virtuoso copier of his favorite themes than a master at the height of his career: too much light and too many reflections animate the scene, in their view. The large painting in the background could be a *Love Triumphant* by Van Everdingen, already seen in *Girl Asleep* and in *Girl Interrupted at her Music*.

The following pages contain: some documents useful for understanding different aspects of Vermeer's life and work; the fundamental stages in the life of the artist; technical data and the location of the principal works found in this volume; an essential bibliography

DOCUMENTS AND TESTIMONIES

Who was his teacher? A question without an answer

From 1652 to 1654, the year when he died from the injuries suffered in the explosion of the Delft municipal gunpowder warehouse, Carel Fabritius, a well-known and highly regarded artist who had studied un-

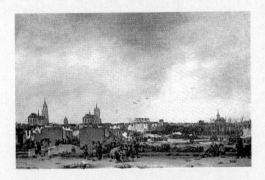

der Rembrandt, was in Delft. Many critics, on the basis of a controversial interpretation of some lines from a poem published by Arnold Bon in 1668 in the Description of the City of Delft by Van Bleyswijck, have indicated Fabritius as Vermeer's teacher. The lines, although not excluding the possibility of a continuation between one and the other, are however completely insufficient to prove this claim:

"Thus this Phoenix was extinguished,
To our loss, at the height of his power.
But happily there arose from the fire
Vermeer, who followed in his footsteps
with mastery."

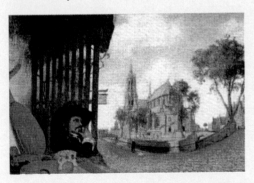

An authoritative expertise by Vermeer

On May 23, 1672 Jan Vermeer and Johannes Jordaens were called to The Hague to give their testimony regarding the authenticity of twelve Italian paintings. At the time Vermeer was serving as the dean of the Guild of St Luke in Delft, and Johannes Jordaens, as he had spent many years in Italy, was considered an expert on Italian painting. The famous merchant Uylenburgh, who had come into possession of the paintings in question, had offered them to the Elector of Brandenburg Friedrich Wilhelm, who gave the dealer a deposit and kept the paintings while he made his decision. Hendrick Fromantiou, a painter, art expert, and adviser to the Elector, had serious doubts about the authenticity of the paintings and advised the Elector not to purchase them. The dealer refused to take them back, and a dispute arose which went forward with experts being called by one side and the other to give their opinions. The paintings to be examined were attributed to Michelangelo, Titian, Giorgione, Jacopo Palma, Tintoretto, Bordone, and others. The opinions contradicted each other, and the group of supporters on each side widened until it took in Costantijn Huygens, secretary to the prince of Orange-Nassau, Friedrich Heinrich, who defended Uylenburgh's position. Final judgment, to be passed in front of a notary in The Hague, fell to Vermeer and Jordaens, who ruled that the paintings

…"not only were not excellent Italian pictures, but on the contrary were daubs and bad paintings that were not worth even the tenth part of the above-proposed prices."

Their judgment was perhaps a bit harsh, but it brought the matter to a close with the return to Uylenburgh of all the canvases except one, a Head of Saint John by Ribera, which the Elector chose to keep, along with some sculptures, for a value considered equal to the deposit given to the art dealer at the beginning of the whole affair.

An exaggerated Canaletto

Statements by authoritative critics and artists in the past have emphasized above all Vermeer's handling of light and the splendor of his colors, and in any case show us how his works were known and appreciated more in Holland than in other countries, where sometimes the painter was rediscovered by chance.

"This Van der Meer, about whom historians have not spoken at all, deserves special attention. He is a great painter, in the vein of Metsu."

(G.-B.-P. Lebrun, 1792)

"This Jan Van der Meer, whom I only knew by name… must have seen Italy. He is an exaggerated Canaletto."

(M. Du Camp, 1857)

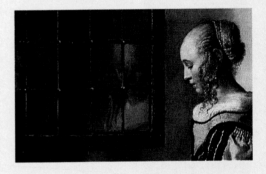

"It seems that the light comes from the painting itself, and ingenuous viewers are happy to think that the light is passing between the canvas and the frame. A man who came into the house of Mr. Double, where *The Officer and Laughing Girl* was sitting on an easel, walked behind the canvas to see from where that marvelous splendor of the open window was coming."

(W. Bürger, 1866)

"Do you know a painter by the name of Jan Van der Meer? He painted a Dutch lady, beautiful, very refined, who is pregnant. This strange painter's palette consists of blue, lemon yellow, pearl gray, black and white… bringing together lemon yellow, dull blue, and light gray is characteristic of him."

(V. Van Gogh, 1877)

HIS LIFE IN BRIEF

1632. Vermeer born in Delft, and in October is baptized in the Nieuwe Kerk (New Church), the second child of Reynier Janszoon Vos, alias Vermeer, and Digna Baltens.

1632-53. None of the documents found to date gives conclusive evidence about the name of his teacher or where he was trained, but hypotheses suggest Utrecht or Amsterdam. As a child Vermeer lived with his parents and his sister Gertruy in his father's inns, first "The Flying Fox" and then "Mechelen," on the main market square.

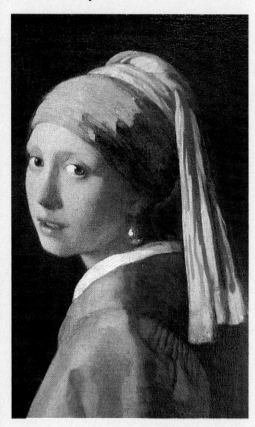

1652. Death of his father.

1653. On April 4, became engaged to Catharina Bolnes, a Catholic, the daughter of Reynier Bolnes and Maria Thins, the descendant of a prominent family from Gouda, and on April 20 in Schipluy they were married in the Catholic Church. At just 21 years of age, on December 29, he became a member of the Guild of St Luke in Delft.

1654. Explosion of the powder warehouse of Delft.

1655. Vermeer and his wife appeared before a notary to guarantee payment of a debt con-tracted by the artist's father with the captain of the Delft civil militia.

1656. This date appears on *The Procuress*, the only painting dated in the years 1650-56.

1657. Economic difficulties forced Vermeer to ask for a loan of 200 florins or, as the current in-terpretation posits, he received this sum as ad-

vance payment for commissioned paintings.

1657-61. There is no trace in the notary archives of his painting activity; he retired to the private sphere, dedicating all his time to painting.

1662. Elected dean of the Guild of St Luke.

1668. This date is inscribed on the painting of *The Astronomer*.

1670. At his mother's death, Vermeer inherited the "Mechelen inn," which he rented out after two years, moving his residence elsewhere.

1672. Once again elected dean of the Guild of St Luke. Called to The Hague to pass judg-ment on some Italian paintings. His name ap-pears on the list of a citizen's militia in Delft.

1675. Sudden and untimely death. His death notice is registered in the Oude Kerk (Old Church).

WHERE TO SEE VERMEER

The following is a catalogue of the principal works by Vermeer conserved in public collections. The list of works follows the alphabetical order of the cities in which they are found. The data contain the following elements: title, dating, technique and support, size in centimeters, location.

AMSTERDAM (HOLANDA)
The Kitchen Maid, 1658-60; oil on canvas, 41x45.5 cm; Rijksmuseum.

The Love Letter, 1667; oil on canvas, 38.5x44; Rijksmuseum.

Lady in Blue Reading a Letter, 1662-65; oil on canvas, 39x46.5; Rijksmuseum.

Street in Delft, 1661; oil on canvas, 44x54.3; Rijksmuseum.

BERLIN-DAHLEM (GERMANY)
Woman Drinking with a Gentleman, 1660; oil on canvas, 76.5x66.3; Staatliche Museen Gemäldegalerie.

Lady with a String of Pearls, 1662; oil on canvas, 45x55; Staatliche Museen Gemäldegalerie.

BOSTON (UNITED STATES)
The Concert, 1665-66; oil on canvas, 62.8x69.2; Isabella Stewart Gardner Museum.

BRAUNSCHWEIG (GERMANY)
Couple with a Wine Glass, c. 1660; oil on canvas, 67.5x78; Herzog Anton Ulrich Museum.

DRESDEN (GERMANY)

Lady Reading a Letter at an Open Window, 1657; oil on canvas, 64.5x83; Gemäldegalerie.

The Procuress, c. 1656; oil on canvas, 130x143; Gemäldegalerie.

DUBLIN (IRELAND)

Lady Writing a Letter with her Maid, 1670; oil on canvas, 60.5x71.1; National Gallery of Ireland.

EDINBURGH (GREAT BRITAIN)

Christ in the House of Mary and Martha, c. 1654; oil on canvas, 141x160; National Gallery of Scotland.

FRANKFURT (GERMANY)

The Geographer, c. 1669; oil on canvas, 46.5x53; Städelsches Kunstinstitut.

THE HAGUE (HOLLAND)

Diana and her Companions, c. 1654; oil on canvas, 105x98.5; Mauritshuis.

Girl in a Turban, 1664-65; oil on canvas, 40x46.5; Mauritshuis.

View of Delft, 1661; oil on canvas, 118.5x98.5; Mauritshuis.

LONDON (GREAT BRITAIN)

Girl Refusing a Glass of Wine from a Man (*attributed*), 1660-65; oil on canvas, 92x117; National Gallery.

Lady Standing at a Virginal, 1671; oil on canvas, 45.2x51.7; National Gallery.

Lady Seated at a Virginal, 1670; oil on canvas, 45.5x51.5; National Gallery.

The Guitar Player, 1667; oil on canvas, 46.3x53; Kenwood House, Iveagh Bequest.

NEW YORK (UNITED STATES)

The Allegory of Faith, 1670; oil on canvas, 89x114; Metropolitan Museum.

Young Woman with a Water Jug, 1658-60; oil on canvas, 40.5x45.7; Metropolitan Museum.

Mistress and Maid, 1666-67; oil on canvas, 78.1x89.5; Frick Collection.

Girl Asleep, 1657; oil on canvas, 76.5x87.5; Metropolitan Museum.

Girl Interrupted at her Music, 1660; oil on canvas, 44.5x39.4; Frick Collection.

Officer and Laughing Girl, c. 1657; oil on canvas, 43x48; Frick Collection.

The Lute Player, 1663-64; oil on canvas, 46x52; Metropolitan Museum.

PARIS (FRANCE)

The Astronomer, c. 1668; oil on canvas, 46.3x50.8; Louvre.

The Lacemaker, 1665; oil on canvas, 21x24; Louvre.

VIENNA (AUSTRIA)

The Allegory of the Art of Painting, 1662-65; oil on canvas, 100x120; Kunsthistorisches Museum.

WASHINGTON (UNITED STATES)

A Lady Weighing Gold (or Pearls), 1665; oil on canvas, 38x42.5; National Gallery of Art.

A Lady Writing, 1665; oil on canvas, 36.8x47; National Gallery of Art.

BIBLIOGRAPHY

For an extensive list of studies on Vermeer, which includes not only monographs but also sales catalogues, see the bibliography for the entry on Vermeer, compiled by E. Trautschold, in *Allgemeines Lexicon der Bildenden Künstler*, by U. Thieme and F. Becker, XXXIV, Leipzig, 1940. For archival documents, the volume by J.M. Montias offers a list of 454 documents which the reader might find of interest.

1954 V. Bloch, *Tutta la pittura di Vermeer di Delft*, Milan

1961 P. Kurz, *Falsi e falsari*, Venice

A.P. Mirimonde, *Les sujets musicaux chez Vermeer de Delft,* in *Gazette de Beaux-Arts* 103, 57

1966 H. Gerson, *Johannes Vermeer, Enciclopedia Universale dell'Arte*, XIV

P. Descargues, *Vermeer*, Geneva

1967 G. Huizinga, *La civiltà olandese del Seicento*, Turin

P. Bianconi, *Vermeer. L'opera completa*, preface by Giuseppe Ungaretti, Milan

1976 E. De Jongh, *Tot lering en Vermaak*, exh. cat., Amsterdam

1982 J.M. Montias, *Artists and Artisans in Delft: a Socio-Economic Study of the Seventeenth Century*, Princeton University

1986 J.A. Welu, *Vermeer's Astronomer: Observations on an Open Book*, in *Art Bulletin* 68, pp. 263-67

1989 A. Aillaud, A. Blankert, J.M. Montias, *Vermeer*, Milan

1990 S. Danesi Squarzina, *Vermeer*, in *Art Dossier* n. 45

1997 J.M. Montias, *Vermeer. L'artista, la famiglia, la città*, Turin

ONE HUNDRED PAINTINGS:
every one a masterpiece

Vermeer
The Astronomer

Titian
Sacred and Profane Love

Klimt
Judith I

Matisse
La Danse

Munch
The Scream

Watteau
The Embarkment for Cythera

Botticelli
Allegory of Spring

Cézanne
Mont Sainte Victoire

Pontormo
The Deposition

Toulouse-Lautrec
At the Moulin Rouge